# SKOGLUFT

/skog-looft/

## FOREST AIR

# SKOGLUFT

*/skog-looft/*

## FOREST AIR

Norwegian Secrets for Bringing Natural
Air and Light into Your Home
and Office to Dramatically Improve
Health and Happiness

# JØRN VIUMDAL

TRANSLATION BY ROBERT FERGUSON

HARPER
DESIGN
*An Imprint of HarperCollins Publishers*

Originally published as *Skogluft* by Panta Forlag, Oslo, in 2018. Copyright © Jørn Viumdal

SKOGLUFT. English translation copyright © 2019 by Robert Ferguson.
For information address Harper Design, 195 Broadway, New York, New York 10007.

HarperCollins books may be purchased for educational, business, or sales promotional use. For information please email the Special Markets Department at SPsales@harpercollins.com.

Published in 2019 by
Harper Design
*An Imprint of* HarperCollins*Publishers*
195 Broadway
New York, NY 10007
Tel: (212) 207-7000
Fax: (855) 746-6023
harperdesign@harpercollins.com
www.harpercollins.com

Distributed throughout the world by
HarperCollins*Publishers*
195 Broadway
New York, NY 10007

ISBN 978-0-06-289622-3
Co-Author: Christian Heyerdahl
Editor: Agathe Skappel
Design: Sunila Tuft, Panta Forlag
Illustrations: Sunila Tuft, Panta Forlag
Photographer: Nadia Norskott
Stylist: Silje Aune Eriksen
Fonts: Panta
Printer: LSC Communications

Library of Congress Control Number 2018960528
Printed in the United States of America

# CONTENTS

# PREFACE

Suppose I were to tell you that there is one single thing you can do yourself that will change your life. And it's not about learning how to pull yourself together, exercising more, or thinking the "right" thoughts—it's about adding something that's been missing from your life.

This one single thing strengthens your immune system, counteracts tiredness, reduces everyday stress, and gives you not only more vitality, energy, and joy in life but also better general health. All this from one single thing.

I can prove it. We have twenty years of research behind us. Thousands of people in Norway have experienced this change in their everyday lives.

You don't need to change your lifestyle. You don't need to give up anything. You don't need a will of iron. Just a few simple steps will create a change that will give you more energy for what is most important to you: family, job, and friends.

You'll be able to discover a way to see the world with new eyes. You'll feel that you are a part of something living and authentic. You'll be able to create harmony and purpose in a daily life replete with meaningful rituals. And in creating a healthy, fresh space, you will be laying the foundations for an even better life.

# INTRODUCTION

## The *Skogluft* (Forest Air) Method

In the preface I made a number of claims about the effect of the Forest Air method, and you may want to see proof. You will! By the time you have read this book, and perhaps tried the system yourself, I don't think you will find the claims unreasonable.

First let me give a brief overview. The idea behind Forest Air is about bringing plants and light into the rooms in which you spend most of your time—the *right* light and the *right* plants. This can't be done just any old way, but it isn't difficult to do correctly. I have a good reason for saying this.

I've been working with plants for more than thirty years. My initial training was as a mechanical engineer, which is probably why I began my work with a much too simple and mechanistic view of the relationship between nature and humans. I've since realized that every living thing is unpredictable. Living things have the power to surprise you with new, more complex connections—just when you thought you understood how it all works. Yet

IT'S ABOUT BRINGING PLANTS AND LIGHT INTO THE ROOMS IN WHICH YOU SPEND MOST OF YOUR TIME–THE *RIGHT* LIGHT AND THE *RIGHT* PLANTS.

at other times the connections are much simpler than you had supposed. (Your education is never over.) *Forest Air* is a book in which I have tried to assemble some of the thoughts and experiences I have gleaned from my work and show what their practical significance is for us humans. But most important of all, *Forest Air* is a simple guide to how to get nature back into your life, every single day.

Since the rise of the environmental movement in the 1970s, the importance of nature to humanity has been an integral part of the global conversation. What was once considered controversial is now regarded as sound common sense. No one doubts any longer that we are dependent on nature for our survival, and that when nature is destroyed we will all lose. Every day brings yet more sensational news stories of species threatened with extinction, problems with the environment, climate change. For some, the mere mention of the word "nature" is enough to cause anxiety.

Are you one of those who have visions of Armageddon at the mention of the word?

If that is the case, then let me reassure you. You will sigh with relief when I say that yes, this book is about nature (and even about nature that has vanished), and I'm giving you a chance to get it back. And you won't have to travel somewhere far away; instead you can stay in your own home, exactly where you need nature the most and can enjoy it. What I'm talking about is not anything new. In fact,

the idea behind Forest Air is very ancient. Imagine you're at a family gathering and you meet an old relative whom you haven't seen for a very long time. Yet as the two of you begin to talk, it's as though you have never lost touch and you understand each other effortlessly. This is what it will feel like when you get in touch with nature again in the simple way I will describe for you.

The term "nature" has many meanings. When I talk about nature in this book, I am also referring to a sense of togetherness with our surroundings, a sense we lost when we abandoned our hunter-gatherer lifestyle and gradually withdrew from the environment that was once natural for us. And I am also talking about how we can find a way back to a spontaneous communion with our surroundings and experience the joy of seeing, hearing, smelling, feeling, and breathing in an environment that resembles what we left behind.

## THE FOREST AIR WAY

I need to stress that Forest Air is not some mystical philosophy. It's a few simple, practical things you can do on your own that will open up a new dimension in your life. It is not completely effortless. Some of the steps you will have to do yourself. But having said that, I can promise you that there are few things that will reward you so richly for such a small outlay as what I am going to tell you about in this book.

What kind of effort and what kind of reward? I can state it simply, in a few words:

The effort consists largely of setting aside an hour or two, alone or together with family and friends, to mount a simple frame on a wall. There you will plant a group of plants (I will even tell you the name of the plant) and then plug in a lamp with the appropriate kind of light. You might get your fingers a little dirty on the first evening. You might have to drill a couple of holes in the wall and afterward sweep and clean up a bit. And then? After that, all you need to do is water the plants every three weeks and occasionally prune—following a method that I shall teach you. Does that sound exhausting? No, I didn't think it would.

And the effect: Those who have used the Forest Air method relate that they experience a special kind of peace—a sense of presence and contentment. They feel less isolated. They feel more secure. Less tired. And they are astonished that so little effort can reap such rewards.

Frankly, I am not surprised when people tell me this. Our modern, urban lifestyle—filled with stress, noise, and sedentary indoor activities—has separated us from what were once the natural conditions of life. We now live in an environment to which we are truly not adapted and to which our bodies cannot adjust. This creates damaging physical stress and illnesses that we try to cure with pills, exercise, or therapies, often to no effect. But the good news is that many of these stresses can indeed be reduced. Not merely reduced—in many cases you are able to prevent these stresses from arising in the first place by removing their cause. And the name of the solution is Forest Air.

"

Those who have used
the Forest Air method
relate that they experience
a special kind of peace—
a sense of presence and
contentment.

"

## DON'T JUST BELIEVE ME–BELIEVE THE RESEARCH

The Forest Air method is built on solid scientific foundations. The system works at home, in the work-place, and in schools and public institutions. It is simple to install and requires little maintenance or care. The thousands of Norwegians who use it today–men and women, adults and children–all report results that point to a strengthening of the autoimmune system; lowered levels of stress; a reduction in the number of conflicts; improved ease of cooperation with family members, coworkers, or patients; and a more joyful life.

But you don't need to rely solely on anecdotes. Twenty years of research tells the same story.

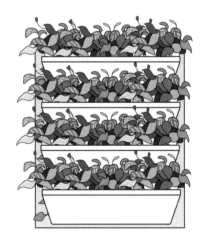

## RESEARCHERS HAVE BEEN ABLE TO PINPOINT THE FOLLOWING BENEFITS:

- You feel increased vitality and energy.
- You feel lower levels of stress as well as a greater resistance to stress.
- You feel the effects of a strengthened autoimmune system, with fewer aches and pains and a more rapid recovery from illnesses.
- You are less affected by the noise, pollution, hectic rush, and traffic of urban life.
- You experience better air quality in your home or workplace, because the plants purify the air of toxins and release healthy biological elements into it.
- You feel calm and markedly more able to concentrate.

## RESEARCH DEMONSTRATES WORKPLACE BENEFITS TOO:

- Increased productivity
- A considerable decrease in sick leave
- Less fatigue, and fewer headaches or complaints of feeling a heaviness in the head
- Greater precision and quality in work processes
- Fewer respiratory problems
- Greater contentment and feelings of satisfaction among personnel

## NO PREVIOUS KNOWLEDGE NECESSARY

You don't need to practice for years or get a degree in order to make this change. It is not strenuous. It is not difficult. And unlike many other methods offering a change of lifestyle, it is not about finding fault in yourself.

If you follow the advice I give in this book, I believe you will experience something like a burden being lifted from your shoulders—a burden you may not have noticed because you thought that was how things were supposed to be.

But I promise you, you will notice once it's gone. This is what living *should* feel like. Don't believe me? Then you most definitely should read on.

## GETTING RID OF THE BURDEN

Imagine you have to lug a heavy burden around with you. Imagine that every morning when you get out of bed, this invisible burden is tied to you, and that it stays with you as you go through your day.

And you are tired. God, how tired you are. You are depressed. You have headaches, muscle pains, irritated eyes, infections. But since you know of no other life, you don't understand why it's like that. You think it's your own fault, and you become good at pulling yourself together to get the job done—whatever job you need to do, from caring for your children to painting houses.

**IF YOU FOLLOW THE ADVICE I GIVE IN THIS BOOK, I BELIEVE YOU WILL EXPERIENCE SOMETHING LIKE A BURDEN BEING LIFTED FROM YOUR SHOULDERS.**

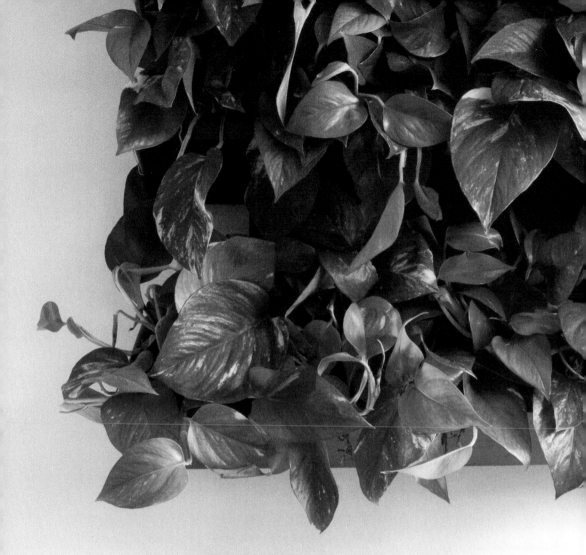

NOW IMAGINE DISCOVERING THAT THIS
BURDEN, THE ONE YOU HAD BEEN CARRYING
AROUND, COULD HAVE EASILY BEEN
REMOVED BY MAKING JUST ONE SMALL
CHANGE IN YOUR LIFE. WOULD YOU BE
ANGRY? YOU BET YOU WOULD!

And because you think the blame lies with you, you have tried self-help, doctors, pills, and exercise. One after the other, often at the same time.

Now imagine discovering that this burden, the one you had been carrying around, could have easily been removed by making just one small change in your life. Would you be angry? You bet you would!

But your most pronounced reaction would probably be one of relief.

Relief that there's nothing wrong with *you*.

And that it is so easy to get rid of the burden.

Here's another example: Imagine it is compulsory for everyone to wear sunglasses indoors. At home. At work. At school. In public institutions. And if you protest and say that your eyes are tired, you are told that you lack self-discipline. If you complain of a headache, you are given a pill. If you are tired, you are told to pull yourself together. If you find it difficult to read and write, you are told that the light has been checked and it has been found satisfactory. Clearly, such a world would be nothing but a madhouse. But think about it: Isn't that what it is like for us?

# CHAPTER 1

## THE STRUGGLE IS REAL— AND CAN BE OVERCOME

IF YOU'RE THE TYPE WHO
DAYDREAMS ABOUT THE
MOUNTAINS OR THE SEA OR
THE FOREST INSTEAD OF
MAKING THAT PHONE CALL,
WASHING THAT LOAD OF
LAUNDRY, OR CLOSING THAT
DEAL, YOU'RE NOT ALONE.

# FATIGUE IS ONE OF THE MOST COMMON CONDITIONS IN MODERN SOCIETY

*A gentle breeze blows across the sheltered bay. The sun warms your toes as you wiggle them in the soft sand. You're sitting on your favorite beach looking out to sea, and the distant cries of the seagulls ring in your ears—*

**IT IS NOT A SIGN OF WEAKNESS THAT YOU LONG FOR VACATION**

"Ahem! Ah-*hem!*" That was no seagull—it was your boss. She apologizes for disturbing you and asks: "Is that chair comfortable to sit in?" She thinks you look a little uncomfortable. Maybe you should be looking for a job somewhere else? Somewhere with more comfortable chairs, perhaps? You hurriedly assure her that the chair is excellent for sleeping—I mean, sitting in—and that, of course, you are content with everything. No, no, you weren't sleeping. Yes, yes, you're completely sure. The meeting continues. You sit up very straight in your (not very comfortable) chair and try to focus your wandering attention on the next agenda item. You were lucky. This time.

Some of what makes a vacation feel so different from everyday life can be brought back with you into your home and your place of work.

*Important info*

If you're the type who daydreams about the mountains or the sea or the forest instead of making that phone call, washing that load of laundry, or closing that deal, you're not alone. Many people—including your boss—reminisce fondly about their vacations (and perhaps even a touch bitterly, because they seemed much too short).

At the risk of disappointing you, this book is not about showing how to turn every day into a vacation. Experiencing the peace and contentment of a vacation in the midst of a busy work life filled with obligations is difficult—if not impossible. But some of what makes a vacation feel so different from everyday life *can* be brought back with you into your home and your place of work. And doing this doesn't require complicated feats of technical engineering or a steady drain on your bank account.

How often do you feel tired in the middle of your day, as if you can't possibly take one more meeting or phone call? By late afternoon, have you used up every ounce of the energy you felt in the morning? Have you come to expect this lethargy as inevitable, with the only antidote being a cup of strong coffee or a large candy bar, the sweeter the better?

If your answer is "Why, yes, every day at around 2:30 I want to curl up under my desk or under the laundry hamper and take a long nap," join the crowd—this is, unfortunately, an age-old problem in the history of the human race. More than two thousand years ago, the ancient Romans complained of fatigue as their towns and cities grew larger

"

I have a term for
that nagging sense that
something is missing:
'lacking nature.'

"

and their everyday lives became further removed from nature. Having recently shifted from an agrarian to an urban way of life, they felt the urge to travel out into green areas in search of rest and relaxation.

As in so many other realms, the ancient Romans were forerunners in stress reduction: They recognized that something crucial was missing from their lives and sought out solutions to the problem. Today, there is a plethora of solutions offered by scientific advances and a heightened awareness of the impact of environmental factors. But when you begin to sleepily count the hours to the end of your workday and yearn for a nice hammock in which to sleep the afternoon away, chances are you're not thinking about what lies behind this onset of fatigue. But unlike the Romans, modern people have no idea what lies behind their ailments, and as often as not lay the blame on themselves.

I have a term for that nagging sense that something is missing: "lacking nature." It is a term that gathers together the all-too-familiar symptoms that invariably appear under certain conditions.

What sort of symptoms? Through the thirty years in which I have been researching and developing healthy workplaces, the following symptoms are so common that they can be mistaken for everyday annoyances:

- Headache
- A groggy, heavy feeling
- Fatigue
- Respiratory tract irritations

## UNDER WHAT CONDITIONS DO THESE COMPLAINTS ARISE?

- During the winter
- Usually indoors and in urban environments
- When we cannot see, smell, or touch green, healthy plants
- When the light around us is too weak or too bright

Have you noticed that the symptoms read more like a schoolchild's excuses for staying at home on a particularly miserable autumn day? Compared to a broken bone or the bubonic plague, they really don't seem to be a big deal. You're right to be critical when someone comes along with dubious claims concerning some (usually expensive) means of curing quote common, "trivial" problems. But these small problems are what a great many people face on a daily basis. They aren't excuses but symptoms we experience when we don't feel ill enough to skip school or work (even though we would very much like to). And in many sectors, such as security and health, these problems are not at all minor matters. They can be the difference between a right decision and a wrong one—a choice that can be the difference between life and death.

NOTE HOW
TWO ELEMENTS
IN PARTICULAR
RECUR

-

A LACK OF LIGHT
AND A LACK
OF PLANTS.

Look again at the four types of conditions (see page 29). Note how two elements in particular recur—a lack of light and a lack of plants. And note another important distinction —there are conditions over which we have no control.

We can't change the seasons of the year, for example, although some people are able to travel to seek out light and nature. And unless we happen to be high up in the command chain, we can't do much about access to light and to nature in places where we work or in public spaces. But note there are conditions we *can* change. Hence the two reasons why I wrote this book.

*Important info*

The Number 1 Reason:
**WE NEED TO UNDERSTAND EXPERIENCING A LACK OF NATURE IN ONE'S LIFE IS A PROBLEM.**

The Number 2 Reason:
**THIS PROBLEM HAS A SIMPLE SOLUTION.**

So the next time you feel a headache, fatigue, or a nagging cough, don't dismiss it. It's easy to disregard these vague symptoms—when we can't pinpoint a reason for why

we feel bad, we presume that we're imagining our symptoms or that we're weak. And that is why we assume that the ailments will disappear if we just pull ourselves together. That is why we feel the solution is a matter of willpower.

## WHERE THERE IS A WILL, IS THERE A WAY?

Willpower is like a modern-day superpower—we say it can conquer everything from obesity to addiction, clutter to bad grades. If you have used willpower to overcome a bad habit or to teach yourself something new—congratulations!

Willpower enables us to triumph over petty egoism and reach higher goals, for the benefit both of oneself and others. It gets us involved in issues that truly matter. And yes, willpower can also be put to such pursuits as competing with friends to see who can hold their breath underwater the longest, staying awake to binge-watch a favorite TV series, or scaling Mount Everest without oxygen. As fun or impressive as these feats might be, we could say that they take a lot of energy (or even waste it). The reverse side of willpower, so to speak.

We also use willpower to force ourselves to do things that might be detrimental to our health. Does it make sense to "pull ourselves together" in order to survive in circumstances that are harmful, just to demonstrate that we can? Would you, for example, sleep on a bed of nails every night simply to prove that—well, I really don't know what that would prove, other than that you have a lot of nails.

**SO THE NEXT TIME YOU FEEL A HEADACHE, FATIGUE, OR A NAGGING COUGH, DON'T DISMISS IT.**

*Example*

Let's look at another example. Suppose you've enjoyed a good night's sleep. But by midmorning you're nodding off. Yawning, rubbing your eyes, taking brisk walks to the coffeemaker, you stubbornly resist lying down and sleeping the rest of the morning away. At the end of a long, long day, you feel proud (because we all know that a person who can overcome tiredness has both good willpower and a strong character).

But there might be a very simple reason why you feel tired or unwell. Your body is trying to tell you something, sending subtle messages like "The light in here is very poor. Is it evening already? Might as well take a nap," or "This place isn't good for us. Let's get out of here." When the message doesn't get through, then it resorts to stronger methods, bringing on headaches, a feeling of lethargy, or bouts of coughing. You begin to feel a little stressed or unwell. And if you ignore these messages, you have again demonstrated a willpower you can be proud of. But at what cost?

Think about using your prodigious willpower to some other end. After all, when you have to use great strength of will simply to accomplish a small task like staying awake, isn't that a little like having to pay a fee every time you use your debit card at another bank's ATM (I will do *anything* to avoid having to pay that fee, including going miles out of

"

# Life is better when you're close to plants.

"

my way to find a bank that does not charge one.) And suppose the fee was as big as the amount you wanted to withdraw? Wouldn't that just be a waste of money? Of course it would! And yet when it comes to our health and well-being, we allow this kind of energy drain to happen every single day of the year. The subtle yet powerful effects of this lack of nature forces us to make unnecessary and exhausting compensations to attain our goals.

## WHO REGRETS HAVING BEEN OUT IN NATURE?

The simple method that takes care of this problem was clearly recognized by the ancient Romans: Life is better when you're close to plants. Many of you are nodding your heads and thinking, "Oh, I *wish* I could spend more time out in nature. I *wish* I could be surrounded by nature the whole day long."

This is where the "recharging the batteries" argument comes in—the idea that we take an hour, a day, or a few weeks off in a beautiful spot in order to relax and replenish our stock of energy, which we then spread out through our everyday lives at work and at home. People refer to this all the time. Especially when talking about other people. ("Nina shouldn't look so tired. She just got back from a vacation.")

When people say "recharge," they think of it like filling up with a green fuel, like having a large reserve of nature that they can run on a little at a time through the days, weeks, and months that separate us from our next immersion in green. It sounds fantastic, and it really is—it belongs in the realm of fantasy.

Don't get me wrong, it isn't imaginary that we benefit from a walk in the woods. And who regrets having been

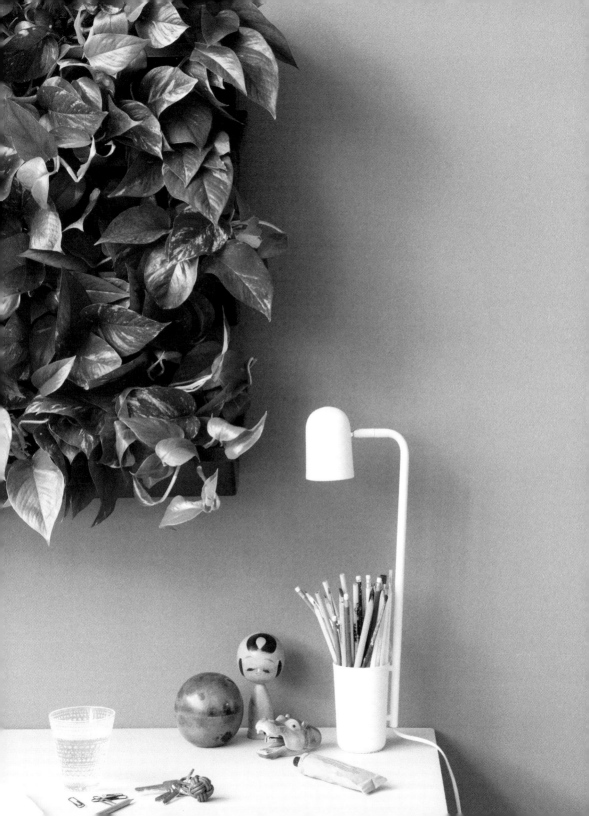

out in nature? The problem is that the effect does not last. You've had a lovely restorative break and you've dived right back into your day with great enthusiasm . . . only to find yourself drained of energy after a couple of hours.

Perhaps, as you again sink into lethargy, you are already telling yourself the usual solution. Like the annoying chorus of a tune you can't get out of your head you hear that repetitive little refrain: "Show some willpower!"

**WE CAN'T POSSIBLY LIE DOWN AND SLEEP AT OUR PLACE OF WORK, EVEN IF THE LIGHT IS SO BAD THE BODY THINKS IT IS NIGHT.**

Willpower works, no doubt about it. It helps us ignore our headaches, tired eyes, coughing, and more. But by using it we suppress the signals the body is trying to send us so that we can follow the short-term dictates of duty and responsibility. We can't possibly lie down and sleep at our place of work, even if the light is so bad the body thinks it is night. We can't possibly stop a task every time we get a headache. We can't possibly go outside and breathe fresh air every time the air indoors becomes too dry or stuffy. We soldier on and carry out the everyday tasks demanded of us. Because we feel we must.

Please, I am not suggesting that we don't use willpower. Don't ever just sit down and give up (or fall asleep under your desk—that would not do). But imagine that the first thing you felt when you entered a room at work or at home was not "Oh no, not another day in this place," but instead "I really look forward to getting started!"

Did you notice that? I wrote about what you *felt* when you entered a room. Whether your energy arrow points up or down is not a matter of personal choice. Even before you start consciously thinking, "Hmmm, the lighting is

rather dim here," or "The air is so stuffy," or even that it's too crowded or sparse, your body has already been paying attention and has made up its mind.

## SPACE DRAIN

Your body is wise. Evolution has honed your senses into a razor-sharp analytical tool that needs just a fraction of a second to deliver an assessment of a situation. The forceful assessment "Get out of here" is still useful after millions of years of dodging predators and environmental hazards, but this course of action might not be a realistic alternative if the assessment comes in the middle of, say, delivering a PowerPoint presentation, negotiating a contract, or working through the umpteenth pile of laundry as a caregiver. But the fact that there are no obvious dangers present doesn't mean that your body isn't sensing something detrimental to your health. When the "fight or flight" response kicks in, being responsible bosses and coworkers and caregivers, we suck it up and pull on our energy reserves. Whether we want to or not, whether we feel "right" about being in whatever kind of environment is triggering the body's response, we have to summon our last resources. Day in and day out.

YOU WOULD HAVE PLENTY OF ENERGY FOR LIVING THE LIFE YOU WANT TO LEAD.

————

Suppose we didn't have to pay this price. Suppose we were spared from making this kind of effort (just to accomplish mundane tasks at home or at work, much less to do what we dearly would like to do). Imagine feeling that your workplace or your home rejuvenates you. Imagine that your senses are

"

Imagine
feeling that your
workplace or
your home
rejuvenates you.

"

reassuring you that you are in a safe, healthy place. You would have plenty of energy for living the life you want to lead. For your interests. Your job. Your children. Your friends.

## FACT: THE ENERGIZER BUNNY IS NOT A REAL PERSON

There must be a better analogy for our energy levels than rechargeable batteries. When I hear people talk about "recharging" themselves, I'm reminded of the old joke about the miser who kept running in and out of his house carrying an empty sack. Why? To save money he had built his house without windows, and now he had to gather enough sunlight for the evening! As any schoolchild knows, you can't store sunlight in a sack. Likewise, you also can't run out and gather up some energy from nature, store it, and portion it out to suit your needs—especially not if you find yourself in surroundings that drain you of energy.

We just have to admit that the term "recharging" isn't accurate. Worse, it's misleading. People don't have anything like batteries for storing energy, so when we use that expression we're actually making unreasonable demands

**I'VE SEEN THAT WE NEED TO "TOP UP" OUR SUPPLY OF NATURE EVERY DAY, 24/7, IN ORDER TO GIVE OUR BEST, AND, MOST OF ALL, TO FEEL HEALTHY.**

———

of ourselves. The energizing, healthful effect we get from walking out in nature doesn't last very long, and it cannot be stored in the form of a sort of dividend that can be paid out later. But are there positive effects to be gained from taking regular walks in nature—and, specifically, the forest?

I've been in the business of improving workplaces and homes for thirty years; time and again, I've seen that we need to "top up" our supply of nature every day, 24/7, in order to give our best, and, most of all, to feel healthy. And there is scientific research to prove this, as you will see. Scientists and researchers have documented a score of specific and measurable physical and mental health benefits from being out in nature. Walking along forest paths, breathing in forest air, and seeing the dappled play of light among the leaves definitely does a body good. However, the problem—which led me to develop the Forest Air method—is that this restorative energy cannot be stored and used later.

Because our bodies don't act like a battery, we tend to be like the miser, scurrying in and out of our homes and workplaces hoping to capture some life-giving rays.

Important info

40

## A DEEP DIVE INTO FOREST BATHING

For years, Japan's national health service has been encouraging people to indulge in *shinrin-yoku*, "forest bathing." I love how the word evokes humans diving into the bushes and splashing about among the leaves, but *shinrin-yoku* simply means going for a walk in the woods (just as many Norwegians do!). The purpose of *shinrin-yoku* is not to lose weight or to get a stamp in your passport or to rack up steps on your Fitbit. (Although all of these, of course, can be part of a bath in the forest.) Instead, the walk should be short and leisurely; exercise is not the main aim. The ancient Romans instinctively turned to nature to feel better. The Norwegians have made a national pastime out of walking in nature. Immersing oneself in the atmosphere of the forest has become an integral part of preventive care and healing in Japanese medicine. What is it the Japanese know that the rest of the world doesn't?

The unmistakable fragrance of a stand of evergreen trees is representative of the fact that all plants exude fleeting organic compounds called phytoncides, which are used not only as a defense against enemies, but also as a way to communicate with other plants of the same species. These compounds, such as the pinenes

Study

and limonenes of evergreens, form an aromatic cocktail that is regarded by the Japanese as highly beneficial for health. Immersing oneself in a forest doesn't just feel calming and restorative; since 2004, researchers in Japan have investigated the effect plants have on health and well-being. Lower blood pressure and anxiety, less irritation and anger, and a strengthening of the immune system were found to be, literally, a walk in the park.[1]

Even in the sterile environment of a research lab, far from a forest, health benefits were noted. Experiments showed that just a *photograph* of a restful nature scene conveying *shinrin-yoku* was enough to cause a drop in blood pressure. Just the scent of certain ethereal oils from forest plants caused a greater drop in blood pressure than other smells. And just touching a natural material like an oak plank had the same effect–an effect that was not demonstrated when this same material was coated with a layer of paint. ·

Experiments were also conducted in the open air. In Chiba, Japan, a control group took a bracing stroll around the city's railway station, while another group walked for twenty minutes in an oak forest in one of the city's parks. The physiological and mental responses of both groups were then tested. The forest group not only showed clear signs of heightened cerebral activity but exhibited improved concentration. The forest group also had a lower count of cortisol compared to the control group. Cortisol is known as the "stress hormone" for good reason, as a high level of cortisol is one of the signatures of elevated stress. A short walk among the trees was all that was required to lower the concentration of this hormone–to *de*-stress.

Another of these experiments, carried out in 2010, tested the nervous systems of participants who were split into two groups, one walking in the forest and one walking through a built-up urban environment. The forest group had lower levels of cortisol, lower pulse rates, reduced blood pressure,

an increase in the activity of the parasympathetic nervous system, and a reduction in the activity of the sympathetic nervous system. These last two results were particularly exciting for me to see.

Remember learning about the nervous system in biology class? The *sympathetic nervous system* is the part of the autonomic nervous system that enables us to react swiftly to dangerous situations (the "fight or flight" response), while the *parasympathetic nervous system* is what calms us down when the danger has passed. So elevated levels of activity in the sympathetic nervous system means that you are prepared and ready for conflict. Our ancestors had to deal with fierce predators, while today our bodies seem to get keyed up to fight (or flee) at the drop of a hat. (Just think of the tension and anxiety you feel in a traffic-snarled commute.)

Researchers were able to document a very important connection:

Shinrin-yoku *soothes your unease and helps calm you down after agitation.*

And for those who suffer from debilitating anxiety or illnesses, later studies have also shown that green surroundings have a favorable impact on chronic stress. An experiment carried out in the 1990s at Hokkaido University showed that *shinrin-yoku* led to a significant lowering of the levels of blood sugar in people suffering from type 2 diabetes, on average a change from 179 mg/dL (before a walk in

Later studies have also shown that green surroundings have a favorable impact on chronic stress.

*Important info*

CORTISOL IS KNOWN AS THE "STRESS HORMONE" FOR GOOD REASON.

A SHORT WALK AMONG THE TREES WAS ALL THAT WAS REQUIRED TO LOWER THE CONCENTRATION OF THIS HORMONE.

the woods) to 108 mg/dL (after). Does the length of a walk matter? In this experiment, apparently not: Subjects walked between two miles and four miles, but the length of the walk had no impact on the results.[2] Good news for those of us who just don't have the time to walk for hours every day, as much as we would like to!

Study

## BUT YOU CAN'T TAKE IT WITH YOU

Around the world, researchers back up the claim that a simple walk in the woods works wonders. As much of the world's population now lives and works in cities, the question for researchers then became how different urban environments might effect one's sense of well-being. Finnish researchers in Helsinki, in a study published in 2014, investigated just that. In three groups, participants traversed busy city streets, a green space in the middle of the city, or a wooded area. Would they feel restored? Filled with vitality? More creative? Hands down the wooded area made people feel the most restored, vital, and creative, but the city park also had a marked positive effect on the participants' well-being. Another striking observation? Stress levels not only went down, they went down quickly.[3]

People feel better after taking a walk in a park, but can these feelings be measured? In the United States, researchers at Stanford University studied the psychological effects of experiences of nature on both thoughts and feelings. Subjects were divided into two groups, each of which was to take a fifty-minute walk in the Stanford area in either a high-traffic urban

setting or in a park. A series of psychological tests was conducted before and after the walk. Those who had walked in nature reported lower levels of anxiety, fewer depressive thoughts, and fewer negative feelings. Higher scores in memory tests showed that their intellectual capacity had also increased. Another study made by the same group of researchers investigated the effects of walking in the woods on common urban ailments such as depression and negative thinking. This study too showed measurable physical effects on the activity of the brain: lower levels of activity in the subgenual prefrontal cortex (sgPFC), the part associated with self-centeredness and chronic worrying.[4] Walking in nature *isn't* just a feel-good exercise.

A walk through the woods also helps those suffering from chronic physical pain. In a South Korean study, patients suffering from serious chronic pain participated in a forest-therapy program. These patients showed marked physiological improvement in two areas: heart rate variability (HRV)–the measure of time between each heartbeat and an important factor in maintaining the autonomic nerve system–and natural killer (NK) cell activity, which strengthens the immune system. Participants said they experienced lower levels of pain and felt less depressed, and they described feeling that their quality of life was better.[5] Interestingly, these results are not about the effects of physical exercise or meditation in nature–just hanging out in nature, leisurely walking through the forest.

Don't just take my word for it. Scientists have weighed in. Whether you call it *shinrin-yoku* or a walk in the woods, immersing yourself in nature will:

- *Strengthen the immune system*
- *Ease pain*
- *Lower stress*
- *Have a calming effect*
- *Control blood-sugar levels*
- *Reduce depression*
- *Improve mood*

All from a walk in the woods!

You might have already discerned a small but important problem: You can't take all of these positive benefits with you. On your lunch break, you've just walked out to a park and filled your lungs with the fresh scent of pine trees. You've returned feeling restored, soothed, and ready to tackle the afternoon's tasks. But as you leave the green, light-filled setting and enter an unhealthy indoors environment, you begin to feel that familiar, dispiriting energy drain. It's back to grabbing a chocolate bar or a cup of coffee and our old friend willpower again.

How can we break this cycle? Ever hear the well-meaning but impractical advice "Either you move to the country or you move the country to you"?

The first suggestion works for people attracted to the idea of sitting on a tree trunk in the middle of the woods whittling willow flutes, making calls on bark-hewn telephones, and now and then stirring to shoot a deer for dinner. But if you don't have a job that puts you directly in touch with nature, then this solution is not feasible—most people need to live and work in urban areas. As for the second suggestion, the idea of bringing the country closer to the city and even indoors reminds me of tragic stories I hear about wild animals accidentally entering the world of humans. A raccoon can carry disease. A bear is cute until she is protecting her cubs. A wild animal can cause loss of life and property, not to mention the animal potentially losing its own life. Moving out to the country—or moving the country indoors—just isn't feasible. So thanks for that advice, but no thanks.

"

Either you
move to the country
or you move
the country to you.

"

# WHAT YOU NEED, WHERE YOU NEED IT

As I said before, our bodies are wise. What we most want around us is precisely what we need most from nature: light and plants. I've joined these into a single concept and developed a method: Forest Air.

Experts have demonstrated clearly that incorporating plants and specially adapted light indoors has a huge positive effect on people's physical and mental health, almost as powerful as the effect of actually being out in nature. The effect has been noted in the workplace, in schools and institutions, and across people in all age groups, occupations, and life situations, from doctors, laboratory technicians, and teachers to students, children in preschool, and hospital patients. In essence, it can be argued that it is a universal medicine.

Not to be a contrarian, but I have to argue that no, it isn't. Do you claim to have given medicine to a fish you've released back into a river, or to a captive mouse you've set free in a forest undergrowth, or to a disoriented bird you've helped get out of a house? What you deserve real praise for is that you returned them to the environment to which they are best adapted to live—the only surroundings in which they can grow and thrive. And I think you deserve no less for yourself.

"

Quality of life.
I think you deserve
no less for yourself.

"

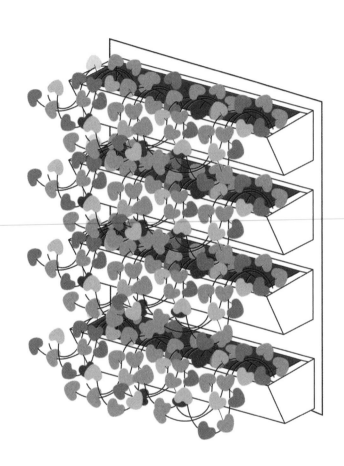

## YOUR NATURAL ENVIRONMENT AT HOME, YOUR NATURAL ENVIRONMENT AT WORK

I'm not suggesting that you carry whole trees into your house (although by all means do so, if you have the space). Nor am I talking about putting some sad little potted plant in a corner. What you get with Forest Air is a small area of living plants that grow in a controlled and predictable way and that you can take care of yourself with minimal effort. And you'll get the same health benefits as you would from a walk in the woods. You experience a *shinrin-yoku* just where you are, every day, without having to go out into the woods.

Say you get a headache while you're hard at work at your desk. You could just take an aspirin, but if you notice that your computer screen is too far from your eyes or your chair is too low, contributing to the headache, you would try to adjust them. We often try to organize elements of our environments so that they are in harmony with our bodies' wants and needs. It is a course of action that will potentially *stop* you from feeling ill in the first place—quite different from taking an aspirin. In the same way, give yourself the chance to see, smell, feel, and touch plants in your everyday environment and provide yourself with good lighting. You will agree: It is not a luxury but rather a daily ingredient that gives you an improved quality of life. Which is something you deserve.

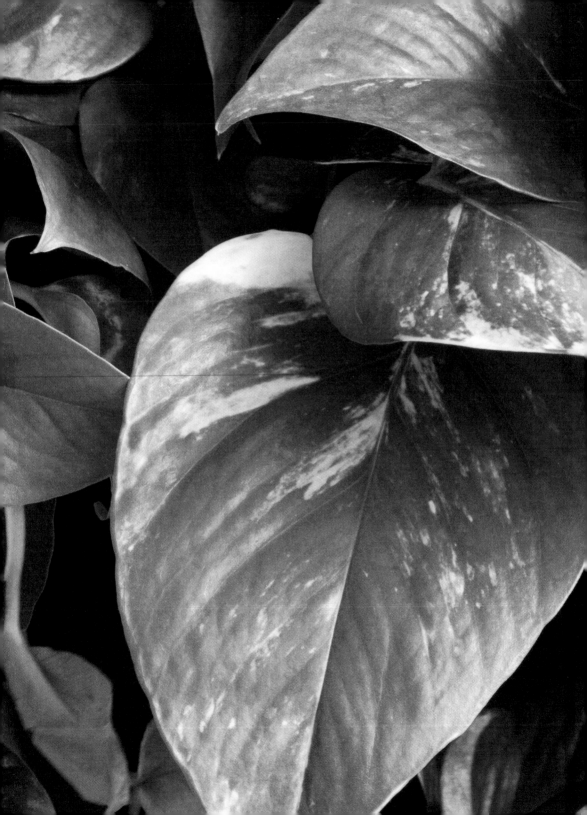

# CHAPTER 2

## OUR FIRST HOME
## (AND OUR FIRST WORKPLACE)

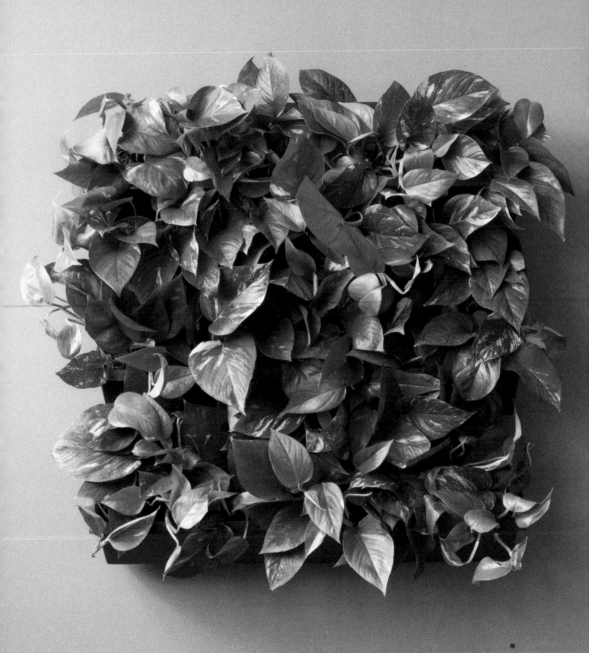

# THE SO-CALLED CAVEMEN
# SPENT MOST OF THEIR TIME OUTSIDE

To adults, childhood feels like a long time ago. And it's been an eternity since our ancestors were young, tending their flocks and weaving their own clothes. Another world. But if we go even further back in time—let's say a hundred thousand years—what were humans like then?

Exactly when *Homo sapiens* began their journey out of Africa is still debated, but their world within that continent was certainly extraordinarily different from ours, filled as it is with modern-day conveniences. With mild temperatures, there was no need for clothes. Humans lived in hunter-gatherer societies, in which most of their time was spent looking for food and hunting game that wasn't quick enough to get away—and keeping an eye out for anything trying to make a meal of them. The kind of society that our ancestors developed was geared to the survival of the species, based on close family groups of twenty to thirty people, in which everyone knew everyone else. All

**THE SOCIETY
WE LIVED IN
HELPED US**

——————

kinds of work—taking care of the children, preparing meals, hunting and searching for food—took place outdoors. Lest one wax nostalgic for what seemed to be a simpler, idyllic life, note that the average life expectancy may have been as low as thirty years. Famine, natural disasters, infections, contagious diseases—throughout our prehistory, humankind has teetered on the brink of extinction on several occasions.

With little to no artifacts surviving from that era, much of what we think about early *Homo sapiens* society is a combination of guesswork and extrapolation from what we observe from modern hunter-gatherer communities. Early humans were nomads who left few if any structures behind as they moved from place to place in search of food. The landscape they moved through, however, is something we do know about. Lush and fertile forests with a canopy of leaves provided just the right mixture of light and shade, as well as plenty of secure places to hide from predators. Humans found that forests also had fresh water, as well as plenty of animals, plants, and bugs for an omnivorous diet.

Anthropologists surmise that early humans wandered extensively, avoiding places that were barren or where the plant life was of poor quality, but determinedly crossing great savannas, deserts, and predator-infested waterways in search of food and shelter. (We might get a bit of déjà vu during a late-night expedition through an unfamiliar neighborhood in search of the best hamburger in town.)

The most secure place to spend the night was probably a spot that provided a little height, along with shelter from the elements—a natural hideaway like a cave, an uprooted tree, or a rocky overhang. Armed with only the tools of the Stone Age, they were never safe from beasts of prey, insects, microbes, and parasites. In such a life, they were always on the lookout for something to eat. Before the leaders of the family group chose their place to sleep, they'd already be planning where they would go looking for breakfast the next morning.

Where we modern people see a lovely path winding its way through a green forest (and pull out our smartphones to take a photograph), our earliest ancestors would be reading the natural signs that told them if water and food would be plentiful and if they would be protected from prey and the elements. What they see would be as clear to them as a flashing neon sign advertising "World's Best Burgers" is to us.

Imagine one of these primitive people suddenly transported to our own time, into one of our modern-day towns or cities.

The "World's Best Burgers" sign is not the first thing he'd notice—he'd be too busy being terrified of a threatening world full of exhaust-belching buses and cars, crowded roads, and towering buildings, not to mention humans' odd hair and clothing. The sheer volume of noise coming from every street corner and radio would alarm him.

ANTHROPOLOGISTS SURMISE THAT EARLY HUMANS BACK THEN WANDERED EXTENSIVELY, AVOIDING PLACES THAT WERE BARREN OR WHERE THE PLANT LIFE WAS OF POOR QUALITY.

## WHEN NATURE VANISHED

A lot of natural hazards familiar to this ancient *Homo sapiens* would have vanished. In a city, he wouldn't need to watch where he planted his next step for fear he might step into a bog or get stung by a scorpion. He could walk around without fear of sharp-toothed predators, and he wouldn't have to fear that he might die of an illness every time it rained or of blood poisoning every time he cut himself. He'd marvel that humans' average life expectancy has increased from thirty years to eighty, and how we live protected from cradle to grave, spared the effort of digging up our food or chasing after it. But probably our ancient visitor's most striking impression, apart from the fact that we still sleep in enclosed spaces that are markedly similar to caves, is that we not only have gotten rid of many natural dangers but have also seemed to have gotten rid of nature itself.

**NATURE IS TOO DIRTY, UNPREDICTABLE, AND WILLFUL.**

And strangest of all: No one seems to care.

If our visitor from the dawn of humankind starts to discuss the shocking fact that nature has vanished from our surroundings, we would protest that this isn't the case: "There is a park about four or five blocks away, and another one a few miles away—a golf course with a wooded area." And the prehistoric human might respond, "But that isn't where you live?"

No, many of us don't live in an actual forest. Whether people live in the city or the suburbs, they've got a litany of reasons for avoiding it: Oh, it's too unpleasant and

dangerous. Nature is too dirty, unpredictable, and willful. It is the abode of snakes, alligators, and stinging insects, and it's a disaster for white jeans.

I'm being facetious, but underlying that avoidance is the one thing that characterizes our species' responses since the dawn of humankind: the fear of extinction. That's why we seek out security, at almost any price. Since humans have begun to build structures, we've come to appreciate that a city a good distance away from the unpredictable nature surrounding it provides protection against danger.

Our prehistory of near-extinctions, natural disasters, epidemics, and fear of wild animals has made creating a safe distance from those threats a natural strategy for us. And even if we are no longer as afraid of nature as we once were—and find it pleasant to romanticize—we still don't tend to invite nature inside our homes. (Not many people condone bears wandering through a city park or scorpions in the nursery, just because "they're natural.") When we step outside our front doors today, our survival against getting eaten by predators isn't our foremost worry. Other problems, like issues with money or friends or office politics, cause us enough worry as it is.

While removing ourselves from nature, we have also discovered new ways of raising the quality of our lives, from medicine and hygiene to preserving food. We have

become better at countering sickness, we're living longer, our affluence is on the rise, and we know more and score ever higher in IQ tests. And that's all good, right? What could be the disadvantages of living a long and safe life?

As for me, I don't believe there are disadvantages. Perhaps this is due to the fact that I grew up in Norway, a place so far north that our prehistoric ancestor wouldn't particularly have enjoyed living there. He would probably have frozen to death if he tried to go out and survive by his own efforts in the middle of the winter.

The history of humankind has been a series of momentous developments. That I sit here writing to you like this would be impossible but for a number of intervening historical events in our civilization.

The most important development was that our prehistoric ancestors set out to wander from their homeland. A natural disaster might have been the impetus, or perhaps it was famine, overpopulation, hostile neighbors, or just curiosity and wanderlust. Waves of migrating peoples flowed between the Middle East and the Arabian Peninsula, heading eastward toward Asia, Oceania, and North America and westward and northward toward what is today Europe. Some species or varieties of the human race drove out or exterminated others, until only the victor was left. The oldest known trace of modern humans in Europe, Cro-Magnon man, is as old as forty thousand years.

The discovery of a group of skeletons in south-western France introduced modern humans to the Cro-Magnons. In this area of France some seventy thousand years ago (long before it became an ideal vacation destination where happy memories are made), an event occurred that would not only affect the continent of Europe for a long time but also continues to do so. The Ice Age.

For a period of about a hundred thousand years, the Northern Hemisphere was covered in a coating of ice more than half a mile thick. And something else was happening that also had a decisive impact on the future of the human race: *Homo sapiens* were evolving and developing formidable social and intellectual powers that enabled them to organize into societies and survive environments where their natural attributes would seem relatively weak–such as the ice fields of Europe.

If you do not have fur to keep you warm in the absence of clothes, you aren't able to run outside in winter very far before you need to sit down and feel sorry for yourself, and you dread getting out of your warm bed when it's cold. Cro-Magnon man was just like you (but was probably in better shape). Cro-Magnons put up with the freezing cold but were not biologically adapted to the area they came to inhabit. Instead they developed social structures, cultural traditions, and technical abilities that made it possible to survive with less effort–and

without freezing to death. Even though they were far from their ancestral habitat of warm Africa, they became such efficient hunters that they hunted several species of mammals to extinction. In due course, as the glaciers melted and the coasts became free of ice, these Cro-Magnons began moving farther north.

And this is where we find ourselves today. Humans have moved far from the green, sun-drenched forests and the warm climate of the original homelands, and we survive by means of cooperation, intelligence, and obstinate, dogged willpower. We do not merely survive. We live longer and experience less pain and sickness with less effort than ever before. But some sicknesses do not disappear. Some get worse. And some completely new ones appear.

You recall how our prehistoric ancestor was impressed by—but critical of—all that we had achieved. Our ancestor would have noted the pills we swallow to ease our anxiety, the nervous way we check our phones, the way we block our ears to keep out the sound of traffic and noise. He would have longed for silence and to stand beneath the shade of a tree.

What humans have done in the course of our evolution is remove ourselves from nature. Now it's as if we keep it at arm's length. There are good reasons for this, and we have made great gains in doing so. But it has not been without a cost.

> **WHAT HUMANS HAVE DONE IN THE COURSE OF OUR EVOLUTION IS REMOVE OURSELVES FROM NATURE. NOW IT'S AS IF WE KEEP IT AT ARM'S LENGTH.**

"

Even though we have
managed to remove ourselves
from nature, we have not
managed to remove nature
from ourselves.

"

## THE PRICE OF PROGRESS

Our ancient ancestors' migrations from the lush forests of Africa mean that we no longer inhabit the region to which we are biologically adapted. We live lives that are very different from the ones our bodies were created for. Regarding ourselves as modern, we think of clothes almost as our skin, and we don't go anywhere without the protection of solid soles under our feet. We regard it as completely normal behavior to sit for hours on a sofa and watch other people's lives unfold on a screen. The walls, ceilings, and floors of our houses are made up of straight lines, something never seen in nature, and our furnishings are rarely composed of anything living. Nature is kept at a safe distance, and in the main we do what we can to avoid direct contact with it. But even though we have managed to remove ourselves from nature, we have not managed to remove nature from ourselves.

**WE LIVE LIVES THAT ARE VERY DIFFERENT FROM THE ONES OUR BODIES WERE CREATED FOR.**

Test

Let me describe two settings for you: First, imagine that you are in an elegant apartment. It is furnished with a mix of the new and the old, all according to your taste. The walls and floor are painted your favorite colors, and the apartment is just the right size for you and yours. With the windows closed, you can barely hear the traffic outside. The air conditioner hums away; the temperature is pleasant. Now the second setting: You are deep within the rain forest. The

air is pleasantly warm. You come to a clearing with a waterfall surrounded by lush green plants. You hear birdsong. The sun shines through the leaves into a pool by the little stream. There is a delightful fragrance of flowers and greenery. You touch the cool water, cup some in your hands, and splash it over your face.

If I were to ask you which of these two scenarios you would prefer to inhabit, you might have to think about it. Common sense says you should choose the nice apartment. You could be drawn to the rain forest, but it takes only a moment to realize that all your daily activities, from brushing your teeth to checking Instagram, are more easily accomplished when you are in the apartment. And you would be right. But your feelings are not the only things that lead you to dream of a life in the rain forest.

(A quick aside: Why *do* people dismiss those yearnings as "just feelings"? What if our feelings are the compass we use to discern what it is we really need? I don't believe that our feelings have been given to us by nature only so that we can cry at movies. They are a tool for analyzing events and situations much more quickly than it takes to formulate a thought—so we can react in time to save a life or deal with a dangerous situation. Just needed to mention this—back to the chapter!)

> Let's try a test. Close your eyes and imagine a place where everything is set up perfectly for you to relax. A genuinely worry-free vacation. The place might resemble the rain forest we were just talking about–but ideally it should also have all the comforts of that luxury apartment. So a modern dwelling in which we also have access to the restorative lushness of the rain forest is about the best thing we can think of. Do you think such a combination is possible?

*Test*

I have to confess that I kept something from you. In the first imaginary picture, the apartment, I failed to mention that the air is actually quite dry, and that something about the apartment makes you sleepy, so you yawn and doze off when you sit down on the sofa, even though you intend to do something that interests you and it's the middle of the day. And that your friends often seem a little tense and uncomfortable when they visit, despite the fashionable furniture. And in the second scenario I completely failed to mention that there is a leopard lying in wait in the long grass. But then perhaps you saw that yourself?

Kidding aside, the paradise we imagine—in this world or the next—almost always has something to do with lush plant life. This is significant! And no, it is not because we are unrealistic dreamers led astray by our unreliable feelings.

**THE PARADISE WE IMAGINE ALMOST ALWAYS HAS SOMETHING TO DO WITH LUSH PLANT LIFE.**

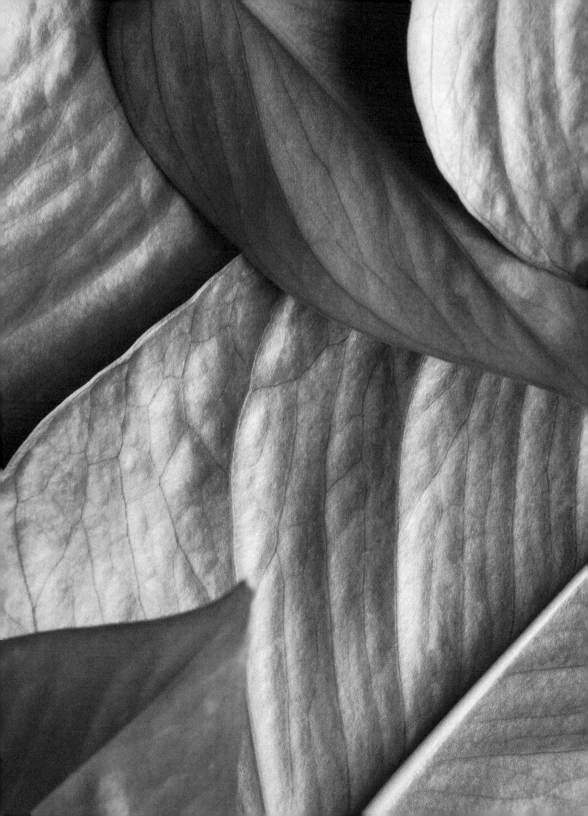

"

Lush plants
and sunlight give
us confidence in life
and in our future.
We can relax.

"

## FINDING SECURITY

The reason we imagine lush plant life is this: Inside we are not the well-dressed and smart creatures we see every time we pass a mirror. In biological terms we have not changed much from the time when we lived in the African forests. Inside we are the same hunters and gatherers who roamed in search of food some hundred thousand years ago. And we are still looking for more or less the same things our ancestors were looking for: food and water.

We find food and water in places that are green and fertile, just as in our rain forest fantasy. We are instinctively drawn to such places. It's not just "feelings" we're talking about here. Deep down, even a hundred thousand years later, it's still important that our environment has enough light for us to find the food we're looking for, and so we can feel confident that we will see any enemy who might be lurking in the undergrowth. The plants need it, our food needs it, and we need it. This light our ancestors responded to so positively, as we do now, is a white, clear sunlight, filtered through a canopy of leaves. Lush plants and sunlight: That's how simple it is. These two factors tell your instincts that all you have to do is get to digging among the roots and the bugs. Lush plants and sunlight give us confidence in life and in our future. We can relax. (Even if we have to keep an eye out for leopards.)

In biological terms we have not changed much from the time when we lived in the African forests.

*Important info*

We also need shelter, and this is where our homes come in. Humans still require a safe spot to retire to for the night, for when a woman is about to give birth, or for when a person is sick and needs to rest. The best shelter would be a hilltop fortress, but that requires a rather large amount of space. (And our cities would look pretty strange if everyone chose that solution.) That's why cabins, caves, or (if you prefer) apartments are the ideal shelter. And they provide our other important need: protection.

Bright sunlight and fresh green plants help us feel optimistic, because they speak to us of fresh water and an abundance of food. Lush vegetation is a sign of nature in balance, where edible plants and our prey (who are also our enemies) thrive. Food from such places has a particularly high nutritional value, and your body instinctively knows it, even if a modern human might turn the leaves over nervously in search of a list of ingredients. But there is another side to this: If we can't see green plants and we don't get the light we need, then we fall ill. When we have to spend time in a place our bodies instinctively know is unhealthy, we have to expend energy to get us through the experience. This wears us out. A lack of nature drains us of strength.

*Important info*

A lack of nature drains us of strength.

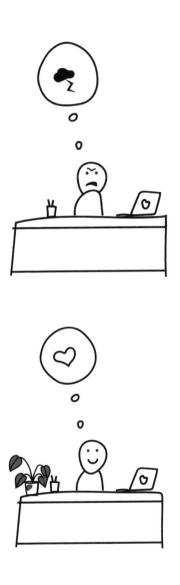

## THE FOREST AIR PROMISE

*Skogluft*, Forest Air, isn't something I picked up at a hippie retreat. It isn't an advertisement on behalf of a light-bulb producer or a garden-supplies chain. It is the result of research and experience.

You have learned about the conclusions reached by Japanese, American, Finnish, and South Korean researchers: what is wrong with us, and what the remedy is. I've explained why we feel the way we do: We have moved far from our original ancestral home in the forest and feel truly well only when we encounter surroundings that offer exactly the elements our bodies instinctively need. We need to smell the presence of nature and see the right kind of light around us. Not simply once a week, but all day, all the time—and especially when we are indoors.

"Impossible!" you say. Let me show you how possible it is.

## MY PROMISE

Remember your vacation fantasy? As you recall, it was about taking the rain forest inside your apartment with you. And you know what? I am convinced I can do it. So convinced that I'll sign this contract:

# CONTRACT

*I, Jørn Viumdal, hereby promise that I can create the vacation mood of the rain forest inside a luxury apartment.*

*Signed:*

_____

I hope you had already realized you have to provide your own apartment. But I can take care of the rest. In following the instructions in this book, you will, in a few easy steps, be able to turn your own home into a green oasis, ready to entertain visitors from the Stone Age at any time. It really isn't such a risky business.

- It isn't expensive.
- It isn't difficult.
- It doesn't require much room.

### AND WHAT'S MORE:
- You'll feel more alert.
- Your mood will improve.
- You'll feel more present in your own life.
- You'll know the joy of seeing growing things around you.
- You'll feel a sense of belonging and connection.

- You'll enjoy health benefits of the kind you'll notice every day.
- Your children will be more relaxed, their powers of concentration will improve, they'll have more energy, and they'll be less quarrelsome.

### BUT REMEMBER:
A little work is required (you need to water the plants every third week) and watch out—this can be highly addictive.

# CHAPTER 3

WE ARE CAVEMEN AT HEART

As someone born
into the modern age,
you've won a kind
of lottery prize in the
history of humankind.

# THE URBAN AND TECHNOLOGICAL LIFESTYLE CREATES STRESS, WORRY, AND FATIGUE

As someone born into the modern age, you've won a kind of lottery prize in the history of humankind. Particularly in developed countries, we have reached a level of affluence and comfort that was unknown to previous generations. Few freeze or starve or die of a deficiency disease. Advances in medicine, technology, and engineering enable us to prevent many of the risks that would have cost thousands of lives even as recently as the last century. Most of our societies are run according to a rule of law that aims to create predictability, fairness, and stability. Many contagious diseases have been eradicated, while others can be contained. With the daily struggle to survive less demanding than ever before, we are living longer. Our greatest problem—pollution from industry, farming, the provision of energy, transportation, and mining—is being taken more seriously.

**WITH THE DAILY STRUGGLE TO SURVIVE LESS DEMANDING THAN EVER BEFORE, WE ARE LIVING LONGER.**

TODAY,
55 PERCENT OF
THE WORLD'S
POPULATION LIVE
IN URBAN AREAS.

My going on about seeking security in rain forests might seem beside the point, as humans have managed to not only overcome the climate challenges that faced us thousands of years ago but also thrive, achieving a high quality of life in many areas and dramatically increased life expectancy. But we pay a price for this.

Ask any commuter trying to get to work on time: City life is challenging to be sure, but perhaps most of all on the social level. Every day city dwellers must interact with huge numbers of people. There are those whom we know and love, others to whom we relate professionally, and in the course of even one day, there are hundreds and possibly thousands whom we pass by, bump into, or otherwise deal with. The sheer number of interactions creates a kind of stress that was unknown to our ancestors, when a close family-based society gave us security in the primordial forest. It's just not feasible to re-create that on a large scale, so it's understandable that we head home after a day's work and shut the door on everyone.

Yet we humans continue to flock to cities in ever-increasing numbers. Today, 55 percent of the world's population live in urban areas, and statistics from the United Nations suggest that the figure will increase to 70 percent by 2050.[6] Most of those who move have no other choice—the city is the only place where they can earn a living.

So city life, a relatively new way of living for humans, now more than ever before means a lot of time spent indoors, without much activity, not much light, and

poor-quality air. The studies I noted by Japanese, American, Finnish, and South Korean researchers show clearly that the urban lifestyle, as comfortable and secure as it seems, actually creates stress and discomfort and can exacerbate conditions like diabetes. Thankfully, the studies also show that green surroundings, like parks and woodlands, can help these conditions.

"So all I have to do is get outside more," you assert. "When I am outside, I get plenty of light, and now and then I see a tree. The real problem arises when I am indoors, and, of course, that is not where I live my life!" Think carefully—how much time do you think you spend indoors on a typical day? Participants in surveys taken in Europe and the United States believed 60 to 70 percent of their day was spent indoors. But the actual percentage of time that emerged shows that in fact over 90 percent of their day was spent indoors. **Ninety percent!**

> The actual percentage of time that emerged shows that in fact over 90 percent of their day was spent indoors. Ninety percent!

*Important info*

It's enough to give some of us a guilty conscience. It sounds terrible to discover just how much time we spend indoors. It's a disgrace, so much so that you might decide to do something about it . . . tomorrow. . . . The fact is that very few are able to choose their lifestyle in any deliberate way. Work, family responsibilities, health, weather, or many other reasons make it difficult to set aside outdoor time in the middle of a busy day, especially if the aim is to experience sunlight and nature. I'm sometimes not much better myself.

Urban life holds yet another hazard to our health and well-being. Our ancient ancestors' lives in the primeval forests may have been nomadic, with family groups wandering over enormous distances, but for months at a time, each group would keep to an area of perhaps a few acres, becoming so familiar with it that they would be quickly aware of the arrival of beasts of prey or other changes in the environment that might threaten the safety of the group. This kind of security is difficult to achieve in an ever-changing, bustling urban environment, in which all public space is shared and there are no natural dividing lines. Truly our home becomes the only place we can rely on for security. It is a lot to ask of a home—whether a tiny studio apartment or a penthouse at the top of a skyscraper.

## BRING THE OUTSIDE INSIDE

A small indoor area is our home—and it is supposed to fulfill the ancestral role of a large forest's tall trees, green vegetation, clean air, and clear, white light filtered through a canopy of leaves. (I can't imagine that a scene like this comes to mind when you think of your home.) But that is why you shouldn't blame yourself for being tired and stressed, unable to give your best at work, at home, and to your colleagues and family and friends. It isn't your fault.

Humans just aren't indoor animals. Our natural element is the forest. And we are creatures of the day—we need the clear, white light of the sun to function at our

best. In being compelled to live a lifestyle that is innately unnatural to us, we miss the lush plants and sunlight of nature. On most of our typical days in the middle of our typical weeks, it is difficult to get the amount of nature we need. And not because we never go outside, but because we don't get to spend enough time out there when we go.

> Humans just aren't indoor animals. Our natural element is the forest.

*important*
*fo*

The indoor life might be our future, but it doesn't have to be our doom. Between home and work, we spend so much time indoors that it's important to do what we can to fill our home and work spaces with the natural elements we need. We can transform these spaces by filling them with the right plants and the right light— with Forest Air.

Feeling fatigued, have a headache or sore eyes, a cough or a runny nose? Lack of nature is a proven factor in these ailments, and so Forest Air is a cure.

> **IT IS DIFFICULT TO GET THE AMOUNT OF NATURE WE NEED.**

## WHAT'S MISSING?

Can't we just put up with a little dry air or poor lighting if we have to—to accomplish deadlines or care for loved ones, for example? That sounds simple to do, but what happens when we come to a new place, whether indoors or outdoors, is that our bodies instinctively examine our surroundings from the perspective of how we might be able

"

Lack of nature is
a proven factor
in these ailments,
and so Forest Air
is a cure.

"

to survive. Our senses "look" for signs of life. Our instincts tell us that where it's green, we can find food, and where there's light—clear, defined light that tells our bodies that it is day, not evening—we have a good vantage point to spot approaching danger. Humans will always prefer to settle in such places, because a healthy environment guarantees that the food found in these places will have the optimal content of healthy ingredients. If a place does not have those key elements, your body will find the surroundings threatening and urge you to get out of there. Even if you, a modern, sensible person, rationally know that you are not in danger of starving to death or dying of thirst, you will hear the message your body sends you.

How many times have you entered a room and felt, instinctively, that something is "off"? If a room is dead, airless, or too dark, no designer sofa or stylish armchair will be able to convince your body that this is a healthy place to be. You might chalk it up to your imagination, yawn a bit, stifle a vague desire to get out of there, and try to shake off the feeling of unease. Only after a while in this environment does it become clear that you feel tired, irritated, or even a bit depressed. These are not "just feelings" but a considered and refined analysis made by your body's defense mechanisms. I think it would be smart to listen to it.

## THE HOME CAVE

You might not describe where you live as a cave, "man caves" notwithstanding. You probably work hard to ensure that the place you live in is healthy, beautiful, and comfortable, not cold, wet, and dark.

So why would I insult your housekeeping and call your home a cave?

Our homes have often been designed by architects with the best of intentions. Natural light, a rational arrangement of rooms, and practical solutions have been the aim for almost a century, ever since the style called functionalism became popular in 1920s Europe. Light and proximity to nature have been among the most important considerations for architects of domestic dwelling places, especially in northern climates.

But with society evolving in the direction of more urbanization and an ever more populated world, cities will inevitably grow denser, with taller, more crowded buildings diminishing access to natural light. Aside from the floor-to-ceiling expanses of the homes of the very wealthy, most new buildings save money on construction by installing narrower windows in smaller rooms. Often all that remain of functionalism's ideals are sharp angles and a rational layout. If you're fortunate, you live near a park or woods or have a garden—but how much time do you actually spend there?

BUT WITH SOCIETY EVOLVING IN THE DIRECTION OF MORE URBANIZATION AND AN EVER MORE POPULATED WORLD, CITIES WILL INEVITABLY GROW DENSER, WITH TALLER, MORE CROWDED BUILDINGS DIMINISHING ACCESS TO NATURAL LIGHT.

Our best intentions of spending time under clear light in green surroundings can easily come to naught, even if we have bought the most expensive house or have the best tenants association to ensure access to rooftop green spaces. In the best living quarters, if the windows aren't large enough or are positioned in such a way that they do not admit enough light, it is impossible to provide the body with anything like the dosage of light and nature it needs.

But even if the weather isn't lovely, even if the park nearby isn't exactly inspiring, it's usually possible to steal a half hour or so in the course of a day for a little injection of nature. You feel rejuvenated, although that effect lasts only a little while after you step inside the door again. It would be wonderful to have that buoyant, relaxed, energetic, restored feeling in the rooms in which you spend your day, every day, all day. Those who have installed Forest Air plant walls at home relate that they experience a feeling of calm, of being present in the moment. They feel less tired and say that the air seems fresher. Here is one person's story.

Example

Alexander, forty-nine, is a single dad with two children. He has a stressful job in media that often involves long evenings working at home. It was hard for him to keep up the pace of work and at the same time be a good father. He told me that family time between school and bedtime was often filled with TV and dozing on the sofa, and there wasn't much communication. But once Alexander installed a Forest Air wall at home, he felt much changed. "I feel a lot less tired," he says, "and it has given life at home a whole new dimension. We've got more energy; we talk more and watch less TV." His nine-year-old son says that what he likes best about the wall of plants is that when he comes home from school and sits down to do his homework, he feels less alone. Alexander himself feels that the growing plants have a very powerful effect on him. "It's almost entirely maintenance free," he says. "They only need to be watered every third week, so traveling away for a week is not a problem. And the last time I returned from a week's vacation, I almost got a shock. The plants had become so big. Even on a daily basis you seem to see them getting larger. It feels incredibly good to be surrounded by something that is growing and thriving like that. It has a domino effect on other aspects of your life."

The effect is noticeable in other ways too. A friend of Alexander's who holds a senior position in the health sector in Oslo visited his home one day and asked what all the plants were. When Alexander described the Forest Air wall, she said firmly, "We ought to have those in our care homes too." For all I know, she's already trying to squeeze that into the budget for next year.

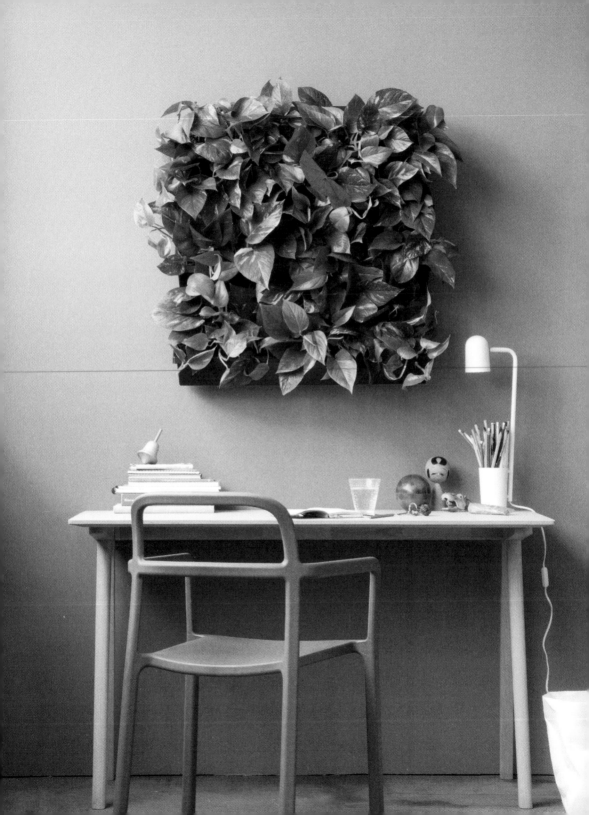

## THE WORK CAVE

Your place of work can feel as uncomfortably dark and airless as a cave—especially on a long summer afternoon. But unless you are responsible for the air-conditioning, the heating, the air quality, and the comfortability of the furniture, there is not much you can do about it.

What is your responsibility, however, is to be in good health and to be bright, cooperative, and open. You need to make the right decisions, and make them quickly. And if you can't, then whose fault is it? The yearly job review will point to you—despite the fact that your work environment is doing its best to drain you of energy. Despite the fact that research proves that these "lifeless" or "dead" rooms are unsuited for tasks that demand precise decision making, alertness, and concentration.

Very few of us go to work and decide, "Today, I'm going to be surly and bad-tempered in the morning, and in the afternoon maybe doze off in my chair before heading for the vending machine and ruining my diet, quarreling with my other half on the phone, and maybe turning up late to collect my kids from preschool." These are not rational choices but reactions to the strain of being exposed to a "dead" room. Can you picture yourself protesting to your colleagues that your bad moods and worse decisions are due to the fact you need light and plants? Can you see yourself meeting with management to point out the connection between lifeless offices with inadequate lighting and the high level of absenteeism? Hardly.

Example

However, some organizations see the connection, such as Google's head office in Norway. Google has a reputation for looking after its employees, with very good insurance arrangements, health care, and a personalized environment at the workplace throughout the organization. But even there, Jan Grønbech, who heads the company in Norway, recognized that the work environment sapped the energy of employees and decided to put an end to that. You might think that a big successful company like Google would solve this problem by just throwing money at it, choosing among the best locations in the capital city of Oslo and developing the most functional and impressive offices. But even big companies face the limitations of budget and the laws of nature. There is a limit to the amount of light you get on a winter's day in Norway, particularly if you move away a little from the windows, and especially when one needs to have offices in the city center, where other buildings block out both the view and sunlight.

On a trial basis Grønbech had Forest Air walls installed in Google's first location in Oslo, ensuring that everything was ready for the opening. By the end of that evening, in which one hundred guests had spent many hours in a space that was thirty-two-hundred square feet,

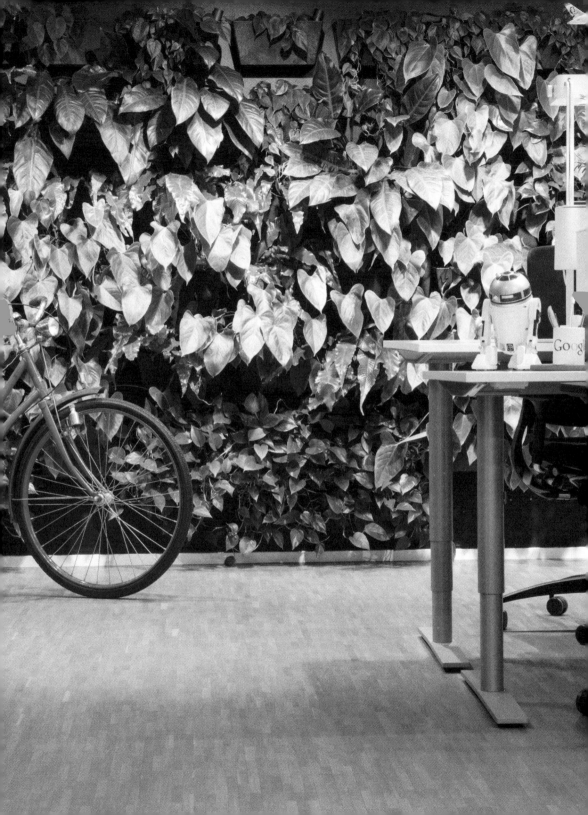

Grønbech reported that "the air still seemed fresh." That convinced him. When Google moved its headquarters to the quayside at the Aker Brygge docks, the plant walls moved into the offices too. He continued: "And I started to notice how this affected people, not least myself. That I no longer find myself yawning, for example. It's as if one never feels tired. You can arrive for work in December, when the sun doesn't rise until ten thirty here in Norway. And yet as soon as you enter the place it's like walking into a forest in the summer. This is in combination with the light, of course, and that the air stays just as fresh throughout the whole working day. You never experience typical office air. So I've become completely addicted to this. If I were to change employers, this would be one of my first demands. I would insist on taking my plant walls with me to my next place of work. Or else you can forget about getting me to work for you. We find that the researchers employed here feel more content and do their work more efficiently.

"So really it's a no-brainer," he concludes, "when you see the effect on the staff. And it's more or less free, really."

And what do visitors say? Grønbech reported that a spontaneous "Wow!" is absolutely the

most common response. And the follow-up: "Do you think we could get this in our offices?"

What, by the way, did Grønbech mean by saying that it was "more or less free"? He meant what a great many other people have said: that the reduction in short-term sick leave pays for the investment. Grønbech used a very simple example to put it in perspective: The cost per Google employee is the same as the cost of a single taxi ride per month.

## FOREST AIR AND THE SKEPTICS

I'd like to introduce you to someone who has real experience with work caves, Turid Langli. She became the director of Oslo's Radium Hospital's radiology department in 1996. The center, about 860 square feet, had sixty people working there. There were no windows and no ventilation–in terms of health, it was a nightmare. This was before the digital imaging revolution, so X-ray films had to be developed with chemicals, with the developing apparatus emitting toxic gases in the very same room where radiologists analyzed the X-rays on large, wall-mounted light boxes. These boxes were the primary source of light in

*Example*

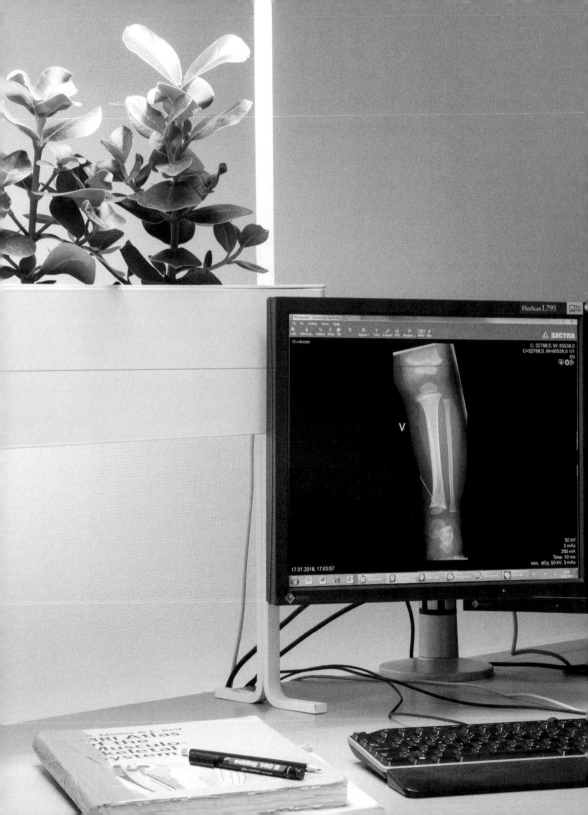

the room, because any other light would affect the analytical process. It is hardly necessary to say that in this environment headaches, dry throats, itchy eyes, and fatigue flourished. One employee revealed that she never dared make an important decision after two o'clock in the afternoon because she was, by then, simply too tired.

Then one day a psychiatrist who was visiting on another matter popped his head into the radiologists' hot and steamy purgatory, quickly took the situation in, and made a crucial observation: "What an ideal place to introduce light therapy."

"What a good idea," said Turid. "So what do you use?" And he told her about using full-spectrum light in light boxes to treat people for conditions such as depression. Turid raced to her boss, Charite Bonnevie. To her surprise, she discovered that Bonnevie had already been thinking along the same lines.

Tove Fjeld, a biologist at the Norwegian University of Life Sciences in Ås, was already conducting a study at the radiology department into the effect of plants and full-spectrum light on the indoor workplace, and I was involved in organizing the practical side of the study. We replaced all light sources, both in the light boxes and elsewhere, with fluorescent tubes emitting

full-spectrum light and set potted plants at all the workstations. The results, which I will describe in detail in the next chapter, exceeded all expectations. I must confess that I was astonished. Absenteeism due to sickness fell from 18 percent to 5 percent in the space of a very short time, and remained there. Problems like headaches and fatigue that had troubled the staff showed a similar decline. There's one very funny story about the potted plant we placed next to the developing machine. By this time we had read NASA's 1989 Clean Air Study, in which the space agency researched using plants to clean the air during future space missions and residencies at space stations. One of their questions was, "Is it possible for plants to extract harmful elements from the air and put them to use for their own growth?" Our potted plant next to the developer looked as though it had decided to confirm the theory all on its own, for the plant grew to twice its normal size. It absolutely *loved* the stinky gases that emanated from the developer. It was not only amusing, but also sobering in what it revealed about the level of indoor air pollution within that work space.

At that time Norwegian hospitals prohibited living plants inside their spaces because of fears of airborne mold, with potentially fatal consequences

*Example*

for patients with weakened autoimmune systems. So we were bracing ourselves for more mold in the air, thanks to the many plants we had installed in the radiology room, and the fact that I was giving them about twenty-five gallons of water every third week, increasing the humidity of the air. But were we in for a surprise! Measurements were made throughout the experiment, and the amount of mold present in the air was discovered to have fallen, not risen. This was yet another result that led hospitals to rethink their practices. Now plants are permitted and even encouraged in hospitals, with their maintenance being carried out by external consultants, not by the nursing staff itself.

Today many radiology departments in Norway have adopted practices that provide light and a good working environment for their employees, and much of the credit for this must go to Turid Langli. For her it was obvious that health personnel, whose job it is to look after others, need to have their own needs looked after by their employers. She gave countless lectures on the effects of green offices and proper lighting in the belief that the road to good patient care must be via a healthy working environment for those doing the caring. Tired workers don't make good workers, and in the health sector

this can mean the difference between life and death. She took our light and plant system with her to her next employer, Ullevål Hospital, where we carried out a similar study and saw the same incredible decline in health problems and absences due to illness.

Turid Langli's involvement has been an inspiration for me to adapt the Forest Air system so that it can be used in all kinds of homes, workplaces, and institutions.

## THE INSTITUTION CAVE

I would like to introduce you to Gunhild. By the time she was interviewed by Oslo's *Aftenposten*, she was ninety-four years old and living in a nursing home. Up until three months before the interview took place, her world had been limited to her chair, where she would spend her days half asleep yet often restless. But then the ward nurse, Eva-Lill Nerlien, had read an article about the effect of light and plants on health and well-being, and decided to give it a try. We replaced the lighting in the corridors and offices with wide-spectrum strip lighting and introduced plants into the wards. The employees reported feeling better. Nerlien herself said that the

Example

headaches she had been suffering had stopped. And Gunhild? In the interview, she says she feels much more alive. Before then she didn't walk much, but walking has become easier for her. She has also gone back to some of her old hobbies, like declining German verbs by heart. She had started reading again.

And that's how little it takes to bring about a real improvement for a generation that never asks for anything.

## THE CHILDREN'S CAVE

I feel passionate about good working conditions for children. *Working* conditions for children, you ask? Yes! Schools and preschools are where children have to concentrate and solve problems. They learn skills and how to understand social rules and norms. Both at school and, regrettably, in preschool, children spend a great deal of time indoors—especially during the winter, when it's already dark enough as it is. Children won't complain about the carpets or demand that the color of their desks be changed, but they do react to a poor environment just as strongly as adults do. It expresses itself directly in their behavior. "Dead" rooms and bad lighting cause fatigue, which in turn makes children feel irritable and aggressive. And because children don't know what's wrong, they're unable to control their behavior or explain why they feel as they do.

"DEAD" ROOMS AND BAD LIGHTING CAUSE FATIGUE, WHICH IN TURN MAKES CHILDREN FEEL IRRITABLE AND AGGRESSIVE.

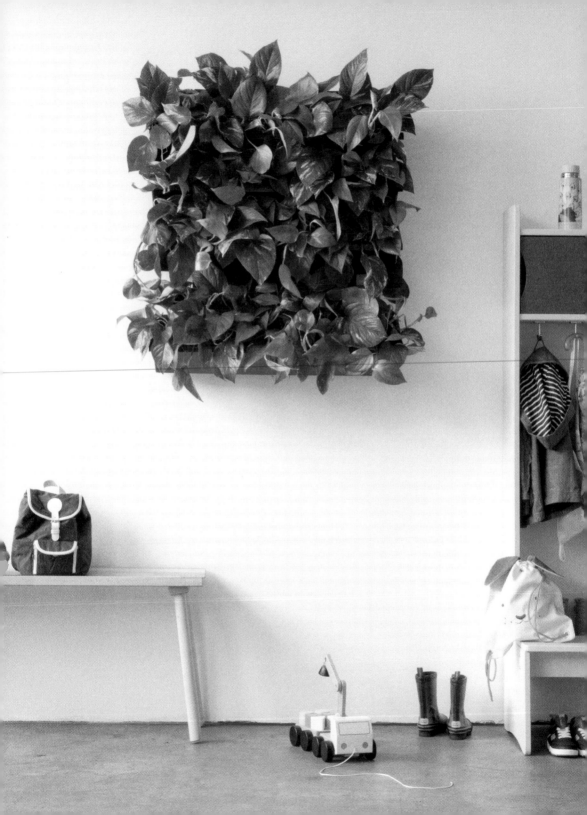

Children's brains are fully occupied in learning, developing, and adapting twenty-four hours a day. Children are busy finding their place in the social network that surrounds them, learning new things, building up their self-confidence, and learning about limits. They don't have time to complain about the interior, the air, or the light.

If there's one place where considering a green environment and good lighting should be obvious, it is for those who are the most vulnerable, who are still growing and developing. This setting is where the most important activity in our society takes place. These are our future mothers and fathers, politicians, nurses, crane operators, hairdressers, and nuclear physicists. Many need extra attention and support.

Those children who struggle most with concentration, learning, and self-control also suffer the most from a poor working environment. To put it simply, they are being deprived of the chance to do their best. Fatigue and headaches, the typical effects of poor lighting and bad indoor air, often result in behavioral problems or irritation, which adults respond to with exasperation—unjustly if understandably, as they are also suffering under these conditions. It's a vicious cycle that affects children and makes the working day even more demanding and distressing for teachers and caregivers.

A child's sudden outburst in a classroom affects more than that child. An episode like this takes up a lot of the teacher's time, attention, and energy. The delicate balance

THERE WAS A MARKED DECLINE IN WHAT THEY CALLED "DIFFICULT EPISODES" IN THE CLASSROOMS FOLLOWING THE INSTALLATION.

"

If there's one place
where considering
a green environment and
good lighting should be
obvious, it is for those
who are still growing
and developing.

"

of a learning environment goes off-kilter, with the other children becoming uneasy and restless. Neither the child who is in distress nor the other pupils are able to learn anything from the lesson. Imagine if one small change in the classroom could stop this domino effect from happening!

I was convinced that Forest Air would effect this change, so I installed plant walls. The staff at several of the schools I've worked with reported that there was a marked decline in what they called "difficult episodes" in the classrooms following the installations, from two episodes a week to none at all. They said that the atmosphere in the classrooms was noticeably calmer, the general mood was better, the children were more responsive, and there was less quarreling. Absence due to sickness went down too, both for staff and pupils.

I quote the words of Niels Bjørn Olsen, in charge of Hundremeterskogen Nursery School in Nittedal, which has several times been nominated for the title of Norway's "Best Kindergarten of the Year."

I had read several articles on Jørn's work and noted the references to the research done on how people respond to poor lighting and what could be done to get the most out of a room. Obviously it's never going to be as good as a walk in the woods, but when we create rooms, we should get as much out of them as we possibly can. Issues of short-term and long-term

*Example*

general health are involved–part of the job for those of us who work in nursery schools. So this is an area of very great interest for us. The children whom we are responsible for are people, after all; they're just not as tall as we are yet, but they can be at least as smart as we are. Sometimes they can be even smarter. What matters most to us is to create the space in which they can become the best version of themselves. And, of course, I can't know in advance what is the best version of themselves; that is something they show us themselves. The installation of Forest Air walls has led to a reduction in health problems for many children. And the parents of those with asthma tell us that there is less need now for medication. We have no objective scientific research that shows a connection, but these developments took place at the same time. And what we didn't know was that the plant walls are free. They cost us nothing, because what we save on short-term absenteeism pays for the plant walls."

*Example*

And if I might be a little cheeky here: If it costs nothing for a preschool with one hundred children, then I think it's probably something you might be able to afford too.

*Three caves, same solution.*

"

We've retreated inside
and locked the door behind
us; facing an absence of
nature in our lives has
become the new normal.

"

## SUMMING UP

When we speak of our primitive ancestors, we might refer to them with a slightly dismissive term: cave dwellers. But what would you call people who spent 90 percent of their time indoors (i.e., many modern-day humans)? Exactly that.

Our caves (or whatever you call the place where you live) still protect us against harsh weather and hostile or dangerous life-forms, much as they did when we lived deep within the forests. When we began to live closer together and formed the first cities, hostile and dangerous life-forms took on a new character. While having many people around may offer a kind of security, that proximity also becomes a burden. A home where one can shut the door provides an opportunity to reestablish one aspect of the natural state—a place where one is surrounded only by those whom one is close to.

If the original purpose of a dwelling place was to give protection from nature's threats, new sources of trouble have arisen since, including door-to-door salespeople or your ex's friends, not to mention all sorts of people we pass by and interact with in our daily lives but don't plan to invite into our homes. More and more we tend to withdraw into our homes, but we always foresee coming out again, at least to run an errand!

Mostly people seem to regard their time spent indoors as a kind of exception to the rule; they consider the outdoor world as the place where they spend most of their time.

IT'S IMPORTANT THAT LIFE INDOORS OFFERS YOU THE RIGHT STIMULI, SO THAT YOU HAVE THE CHANCE TO RECOVER, GET YOUR HEALTH BACK, AND FEEL RENEWED.

While true two hundred years ago, this is no longer the case. We've retreated inside and locked the door behind us; facing an absence of nature in our lives has become the new normal.

> Behind closed doors, our homes continue to serve us. With schedules and commuting, balancing being a parent and making a living, life makes heavy demands on us. We need the time at home to digest our experiences and to prepare us for our next encounter with the world. And that's why it's important that life indoors offers you the right stimuli, so that you have the chance to recover, get your health back, and feel renewed. It doesn't happen through the use of expensive technology or investment in luxuries. All we need to do is, quite simply, surround ourselves with the appropriate natural elements. Green plants and light.

I didn't start out completely convinced of this. At first it was a hunch based on what I'd seen from children and adults when they reacted to a green indoor environment. I had a few theories about the connection between people and plants. I was trying out ways of incorporating plants in a practical way. In the course of my professional career I met many talented experts and researchers. Their hard work helped me prove something that, up until then, I had only had a feeling about. Without them, there might not be Forest Air.

# CHAPTER 4

INDOOR TIGERS

# WHY DO PEOPLE ENJOY BEING WITH PLANTS SO MUCH?

I am a mechanical engineer by training, so when I started working in 1985 for a Swedish firm that provided plants and plant maintenance in the workplace, it was a completely new experience for me. In organization after organization, employees were delighted by the new, green surroundings we created for them. I entered a stimulating technical world that included the Swedish architect Bengt Warne. He was among the first to make use of plants as an integrated part of architecture—both indoors and as a way to connect buildings to their surroundings. A top priority for him was to get as much light as possible into the houses he built. This was what made large indoor areas of greenery possible. His motto: If you build for the plants, then the humans will thrive.

**IF YOU BUILD FOR THE PLANTS, THEN THE HUMANS WILL THRIVE.**

I had always had a feeling that this was true, and meeting him started me thinking, "Why do people enjoy being with plants so much?" I did an impromptu kind of survey at work and even asked people I met in the street. Most

"

We like
being with plants
because they
give us something
we need.

"

replied because plants were, well, nice. No one said they liked them because they matched the sofa or because other people thought they were stylish. And actually no one said it was because they were pretty. Just *nice*.

I figure that when people point out that they enjoy something without offering any specifics, it's usually because that thing meets a natural need. So a reasonable supposition for me was that we like being with plants because they give us something we need. But precisely what is it about plants that creates this feeling of pleasure? And what exactly do plants provide?

> Our customers really appreciated what we did, but I wanted to find out if there was a scientific basis for such a response–basically, if I could find a scientific reason for saying that surrounding yourself with plants indoors is a healthy and positive thing to do. It's very easy to *imagine* that something works. I was familiar with the Hawthorne effect, discovered through a series of productivity studies for the workplace carried out in the 1920s that showed that *any* attention was a useful way of changing behavior. Results showed that simply being aware that you are taking part in a scientific study is enough to bring about a change in your behavior. Were the positive responses from the people I asked simply a case of auto-suggestion?

(Note: Not that the Hawthorne effect is a bad thing. If by asking people to pay attention to what they are doing, you allow them to appreciate the activity anew and increase

the pleasure they get while at work or at home, that is good, even if the appreciation and pleasure aren't necessarily permanent—the Hawthorne effect doesn't last much longer than a couple of months.)

Remarkably, I found that people's reaction to the plants remained at the same high level of positivity month after month, year after year. When we lost a customer, it was usually because they were restructuring or moving. So I had to cross out the Hawthorne effect as a reason. What was happening to cause such a long-lasting positive response?

Everybody has learned in science class that green plants give off oxygen. Through a process called photosynthesis, they transform the carbon dioxide from the atmosphere and water drawn from the soil by the roots into sugar that they use for their growth and to produce oxygen, which we breathe in. Was it possible that people in those offices and institutions were all suffering from a lack of oxygen? Hardly. Were the plants giving off some other secret element? And in that case, what would happen to us if we were deprived of that element?

This line of questioning intrigued me, and I began looking for any other research on the subject. (Note that this was the dawn of the internet era, so finding pertinent research was a more painstaking task than simply tapping out the question in a browser.) After extensive hunting in library stacks and pestering my colleagues, I realized that there had

"

I realized
that there had literally
been more research
done on tigers in cages
than on
people in buildings.

"

literally been more research done on tigers in cages than on people in buildings. The subject didn't seem to be interesting enough to be taken seriously.

But then it occurred to me that there must be fields of study in which this kind of research would be useful. I ran down the list of the most extreme environments on earth in which a human can be placed. A desert . . . the Antarctic . . . a children's birthday party (kidding). . . . Then it hit me: outer space, of course. Was it possible that NASA had done any investigations in this area?

Yes, and a good deal more than that. Through a colleague at the University of Oslo, I gained access to something new and amazing, something called the internet. It's hard to imagine now, but the internet back then was text based, without a single cat video available for viewing. Nevertheless, on the "primitive" servers that were in use at that time, I discovered thousands of pages of material from a number of research institutes and universities in the United States.

NASA planned to keep humans in space for long periods of time, and plants would be part of the equipment onboard the rockets and space stations of the future. Since it wouldn't be possible to take a

whole Noah's ark's worth of plants along on a trek to Mars, a selection of the most suitable species had to be made. The research involved a number of ordinary plants that could be cultivated indoors, which were studied to analyze what sort of substances they introduced into the surrounding atmosphere.

I pored through the pages enthusiastically, but despite the thoroughness with which the research was carried out both at NASA and at American universities, the conclusions were not clear-cut. Researchers recorded and analyzed hundreds of substances given off by the plants, but nothing occurred in such quantity or was of such a nature that could account for the feelings of pleasure, contentment, well-being, and even health improvements I knew that people experienced when close to plants.

I admit, that gave me pause. Maybe my idea was just something I had made up, based on my own experiences and conversations with people in the workplace and on the street. Or maybe my hunch was correct. I was starting to feel that it would be impossible to prove either way. And that might have been the end of my whole project.

But then I started looking at the question from another angle: Had anyone made the attempt to measure whether plants and light have a positive effect on people's *experience* of mood and health? Surely that would be an interesting study in itself?

And if no such attempt had been made, could I perhaps persuade someone to do it?

**HARD FACTS**
NASA's Clean Air Study from 1989, a series of laboratory experiments involving plants and the effect they had on the surrounding air,[7] held a question that hit me like an electric jolt–they were asking not so much what do plants give off *into* the air, but what do they *absorb* from it. Had the experiments proven that plants have some kind of cleansing effect? I quickly wrote to Dr. B. C. "Bill" Wolverton, who had carried out the experiments, and he provided me with detailed descriptions and statistics. There I found proof that plants had a beneficial effect on an indoor climate. The secret lies not just in the green leaves, as one might imagine. The whole growing environment of the plant is part of the process. The soil along with the fungi and microorganisms living in it are part of a common ecosystem with the plant in which each part communicates and exchanges elements and nutrition and stimulates one another's life processes–and in the process absorbs poisonous solvents like formaldehyde, benzine, trichloroethylene, and nitrogen oxide compounds that typically occur in the air around us.

Study

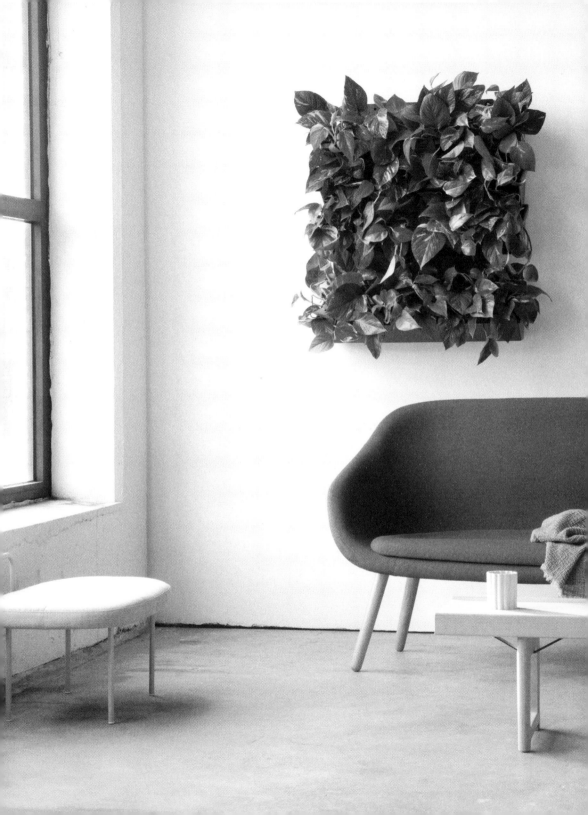

So plants did actively interact with our environment, as I had thought. But they didn't emit magical substances like a forest perfume. Plants draw in air to their roots, with or without the undesirable elements, and through the microorganisms in the soil these dangerous elements were then broken down and turned into fertilizer for the plants. NASA had also discovered which plants were the most efficient in doing this. A lot of indoor plants filter common air pollutants, but some of them are both much more productive and absorb a wider range of elements than others. These plants often grow incredibly quickly—they flourish in environments that our bodies find toxic, just like the potted plants belonging to the radiologists that grew to twice the normal size when placed beside the developing equipment.

There was still one missing piece of my jigsaw puzzle. Dr. Wolverton's impressive work had been laboratory research, but what interested me was how plants functioned with people in an ordinary, everyday environment, among coffeemakers, desks and chairs and carpets, piles of paper and computers, and the thousand other things that clutter the average workplace or the average home. How was I to find that out? Through more research, of course.

But I'm no researcher, and research isn't something you can do at home in the kitchen on your own.

Research calls for costly equipment, professionalism, and expertise. There are strict demands concerning documentation and methods; for example, studies need to be so

**THEY FLOURISH IN ENVIRONMENTS THAT OUR BODIES FIND TOXIC.**

large in scale that incidental variations can be ruled out. It seemed beyond my resources. But I wasn't the only person in Norway interested in this. That was when a colleague of mine first put me in touch with the Norwegian biologist Tove Fjeld. From her own scientific perspective, she had been pondering questions just like mine. And she was a researcher at the Norwegian University of Life Sciences in Ås, specializing in plants, and a leading world authority in her field.

Study

Like me, Tove Fjeld didn't believe in magic pills or fairy dust. Encouraged by NASA's results, she chose a grounded, practical approach to see if we could trace measurable health benefits under ordinary conditions. She carried out the first study in 1996, using an office where more than fifty people worked. Each employee had his or her own enclosed office, with a window covering one complete wall. She and her team designed a pilot study in which half of the workforce had a plant installation of thirteen ordinary houseplants to place next to their desks, while the offices of the control group were improved in other ways, with more attractive and pleasant furnishings, for example, and extra attention from the company's health and safety department. No changes were made to the lighting of either group. Both groups completed a questionnaire composed of questions

about the working environment and how each employee felt about his or her own health, divided into twelve different areas. The management of the company also gave Tove Fjeld access to data on short-term absenteeism and other important information. The study ran for two periods of three months each.

We were heartened by the results, a marked reduction in health problems for the group with plants in their offices, a decline of an average of 23 percent over the twelve points outlined by the questionnaire. Coughing and fatigue? Complaints about these sank by 37 percent and 30 percent respectively. Hoarseness and dry facial skin? Declined by about 23 percent. Nobody reported feeling *more* of these ailments—not even allergies, which people had anticipated. The control group reported no significant improvements in these areas—I imagine they were rather jealous of the other group!

In the previous chapter I described our next research project, also related to conditions in a working environment, which was carried out among the radiologists at the Radium Hospital in Oslo. In the field of radiology before digital imaging, the Radium Hospital's stiflingly hot, dark box of a room was a functional necessity. Radiologists studied

developed X-ray film on a surface backlit by fluorescent bulbs—basically a light box whose light could not be dimmed or brightened. Crucial work was done in this room, with the radiologists' readings a matter of life or death for the patients. Anything that might disturb their concentration, like scattered light or other distractions (plants, for example), were regarded with suspicion, and for good reason. There was a great deal at stake both for those working there and for those of us who were responsible for the project. A whisper of suspicion of a mistake made as a result of what we had done and it would all have been over for both Tove and me, and perhaps even Turid would have lost her job too.

Study

We began by noting the starting conditions, which were extreme. The locale measured only 860 square feet, and sixty workers shared a single room with neither windows nor ventilation. The ceiling light was dim; the only other source of illumination was the light boxes. The temperature was very high. Equipment for developing X-ray pictures–which emitted noxious gases–was located in the same room. Forty-eight employees took part in the study. We placed twenty-three groups of plants around the locale and exchanged the fluorescent lighting in the ceiling and the light boxes with full-spectrum

light that resembled natural daylight. During the first three months the employees were given the same questionnaire that we had used in the previous study: twelve questions concerning self-perception of the subject's health. Anyone who stuck their head around the door would have been able to identify the bad conditions in this work environment and even the two main problems: no windows and no ventilation. But could we really solve this simply by using a natural cleaning agent (i.e., plants) and artificial daylight?

**THE RESULTS WERE SO AMAZING THAT I HAD TO RUB MY EYES TO MAKE SURE I WASN'T HALLUCINATING.**

The results (which I described in chapter 3) were so amazing that I had to rub my eyes to make sure I wasn't hallucinating. The research subjects who were spending most of their working day inside the radiology lab reported a reduction in general afflictions of around 34 percent. Others, who spent less time in the lab but up to half the day in this dark box of a room, reported a 17 to 21 percent reduction in health problems. This didn't just prove that plants and daylight worked. The longer the radiologists spent in the windowless environment, the better their scores in the test results! I tend to be very cautious about reading too much into test results, but these certainly were thought-provoking. To make sure, we carried out a similar experiment at Ullevål Hospital, with almost exactly the same results.

## LOOK FOR YOURSELF: AVERAGE RESULTS FOR ALL RESEARCH SUBJECTS

| Health Symptoms | Percentage Reduction |
| --- | --- |
| Tiredness | 32% |
| Heaviness in the head | 33% |
| Headache | 45% |
| Dizziness | 25% |
| Poor concentration | -2.5% |
| Itchy, burning eyes | 15% |
| Itchy, runny, or blocked nose | 11% |
| Dry, hoarse throat | 22% |
| Coughing | 38% |
| Dry, irritated facial skin | 11% |
| Flaking, itchy scalp and ears | 19% |
| Dry, itchy skin on hands | 21% |

Note the one category in which no improvement was reported–the figure for concentration, which shows a slight decline. Given the limitations on the techniques of radiology outlined above, and the introduction of a number of new elements into the workplace, it is perhaps not so surprising that these hardworking technicians were distracted.

Study

A follow-up study eleven months after the introduction of the new elements showed the same level of improvement.

I couldn't help wondering, though–how much of the symptoms' relief was due to the plants and how much to the full-spectrum light? A new study involving forty-eight participants was conducted in 2001 at a large Norwegian bank. Sixteen employees were given plants on their desks, ten received just full-spectrum light simulating daylight, ten were given both plants and lighting, and for twelve employees no changes were made to the work environment. The average results showed a marked decline in those reporting symptoms such as headache, tiredness, and feelings of heaviness in the head. The biggest reductions were reported by those with both plants and lighting, followed by the plants-only group, and finally the group in which only the light had been changed. According to the Hawthorne effect, those in the control group should have experienced an almost equally strong sensation of change during the three months in which the experiment was conducted, but the figures did not support it.

There have been a score of similar research projects between 1996 and 2014 involving schools and companies. Their results all pointed to one conclusion:

*Green surroundings and full-spectrum light simulating daylight clearly had a role to play in reducing health problems.*

## THE GREEN PILL

People reported health improvements in three areas in particular: fatigue, headaches, and coughing and respiratory problems.

I'll show you the whole table, so you can see for yourself.

| Health Symptoms | Average Percentage Reduction |
|---|---|
| Tiredness | 40% |
| Headache | 35% |
| A feeling of heaviness in the head | 20% |
| Concentration problems | 16% |
| Eye irritation | 16% |
| Nose irritation | 29% |
| Dry and sore throat | 23% |
| Coughing | 37% |
| Dry facial skin | 23% |
| Dry skin on the hands | 4% |

What the figures say is actually sensational. They mean that in a society in which we spend huge amounts of money in combating sickness, there is a simple way to reduce everyday physical discomfort and health problems—one that has been scientifically attested, costs little, and is completely free from harmful side effects.

This is the way I want you to try.

WHAT THE FIGURES SAY IS ACTUALLY SENSATIONAL.

"

The Forest Air
method
in everyday
workplaces reduces
the occurrence
of ordinary
health problems.

"

## AN OUNCE OF PREVENTION

We're good at curing illness in our society. Or at least we have pills for anything that ails us. But what makes the most sense, prevention or cure? To become ill and get well again or not to get ill in the first place?

The figures on page 127 not only portray individuals' personal experiences of their health but show that the use of the Forest Air method in everyday workplaces reduced the occurrence of ordinary health problems. Put another way, Forest Air *prevented* the problems from arising. Headaches, fatigue, sore throats, and coughing—these and other symptoms are our bodies' built-in early-warning system against hazardous environments. And when everything about the environment is right, such warnings are no longer needed.

**FOREST AIR PREVENTED THE PROBLEMS FROM ARISING.**

## CRUNCHING THE NUMBERS

The researchers also came up with other figures—hard facts of a different kind that were incredibly interesting, not just for researchers but also for number crunchers in companies' finance departments and economists in the public health sector too. I'm talking about sick leave. Both the head of one of the biggest corporations in Norway and the head of a preschool believed that the investment in the plant walls of Forest Air practically paid for itself, because the levels of absenteeism due to illness fell. They weren't wrong either; the findings of researchers confirmed what these heads of their organizations experienced.

*Example*

And you know a finding that is even more important? As long as the green installations remained in place, those results continued.

## A SCHOOL FOR GROWTH

Working with light and plant walls at a number of schools, both private and public, I was curious about their impact on the learning environment of the students. In August 1998 an experiment was carried out at two Norwegian schools. In several classrooms, ordinary light sources were swapped for full-spectrum fluorescent tubes that simulated sunlight, and tropical plants were installed using a system that circulated air through the root system of the plants. The students lived with these lights and lush plants for a whole year, after which they were given a questionnaire that asked for their responses on subjects such as their well-being, health, concentration, and symptoms of discomfort.

The results showed again what full-spectrum lights and plants could do. Students felt that the air was cleaner and the classroom more pleasant to be in than in the other rooms where no changes had been made. There were significantly fewer complaints of tiredness, eye irritations, and coughing among those pupils in classrooms with plants. Whereas the control group, whose classrooms had typical lighting and no plants, reported a 12 percent *increase* in health-related problems, the students in the adapted environment showed a 9 percent *decrease* over the same period. Absenteeism was also reduced among these students. What blew me away was that the pupils whose classrooms had full-spectrum light and a plant wall installation showed a *significantly improved ability to concentrate on their work.* A lot of people, teachers especially, will probably agree with me that this is interesting.

One could put it even more strongly. Concentration is the gold standard in all teaching, and if lighting and plants can improve the learning environment for pupils, including those who already have problems in this area, then this is a momentous discovery.

*If a pill had this kind of effect, it would be a sensation. A pill that could do the same thing, and with no harmful side effects, would be epochal.*

"

Lack of nature
makes us ill,
while exposure to
plants and daylight
makes us
well again.

"

Forest Air isn't a pill, but its method is something you can easily follow for yourself. You build the plant wall in an afternoon and follow up every third week to water the plants, and it will give you the same joy and energy every single day for as long as you maintain it. Neither self-denial nor willpower are called for, and the dividends are great. The instructions are simple, so anyone can succeed.

Remember my telling you about the invisible burden you carried on your back all day? That energy you expend just getting ordinary tasks done can be put to some other, better use. Your decision making can be better. You can be a better friend, colleague, sweetheart, and parent—if only you don't have to carry that weight around on your back.

We all do what we can to give meaning to our lives, often at considerable effort. It makes no sense to use up precious energy fighting off fatigue, struggling to maintain concentration, and staving off discomfort. It makes even more sense to avoid these things in a straightforward way.

Lack of nature makes us ill, while exposure to plants and daylight makes us well again.

Maybe it sounds too good to be true? I sometimes used to wonder if we were recording flights of fantasy from our research subjects. And every time I just thought about who were the participants taking part in our tests.

Schoolchildren and infants in preschool aren't interested in interiors, and they don't believe in the healing power of plants. They didn't know that the plants were supposed to have any effect at all. (They probably didn't even

really notice they were there.) If the plants were to work, we would see it most noticeably in the children's behavior. And we did. The results showed a marked improvement in concentration, a reduction in stress, a quieter atmosphere in classrooms, fewer respiratory problems, fewer headaches, and less fatigue. Staff and teachers also reported less quarreling, less acting out, a better social environment, and reduced absenteeism. Children experience things spontaneously through their senses and react with their bodies. (As a matter of fact, adults do too, even though we like to think it's common sense that rules us.) And their bodies made it very clear what they were feeling!

Turning to our second set of users, surely no group could be more wary of pseudo-science than the doctors and nurses at one of Norway's leading hospitals. But here too, among some of the country's most skeptical minds, we saw the same results. Absenteeism fell drastically. And most important of all, this better, higher attendance was maintained through the following years. This was also true for the radiologists and doctors at the Radium Hospital who took part in one of our earliest research projects. I have to smile to myself now and then as I recall the skeptical looks that greeted me the first time I turned up—over twenty years ago now—to see to the plants for them.

## MORE THAN A FEEL-GOOD APPROACH

Let's go back to the question I started out with. What actually is it that causes the plants and lighting to have these effects? I gave up on the hunt for magical substances, but I was on the trail of some of the processes that lie behind the results.

The first is the psychological element. Close proximity to healthy plants seems to induce feelings of calm and contentment and to reduce stress. The Japanese forest bathing experiments showed several health benefits associated with being out in nature, and the Forest Air method seems to reproduce the same effects indoors.

Second is the cleansing effect. Dr. Bill Wolverton's experiments and Tove Fjeld's practical studies demonstrated a distinct reduction in the potentially harmful airborne elements found in indoor settings when plants and the proper lighting are present, and the effect is noticeable, even though the toxins are well below danger levels.

And third is light. The presence of daylight confirms to us that we are right to be awake and alert.

NASA researchers need to hone specific aspects of this complex three-way interaction to send people to Mars. But for ordinary, everyday purposes we just need to keep all three in mind.

Now it's time to talk about living with plants on a daily basis.

**THE PRESENCE OF DAYLIGHT CONFIRMS TO US THAT WE ARE RIGHT TO BE AWAKE AND ALERT.**

# CHAPTER 5

WE CAN DO SOMETHING

LITTLE BY LITTLE,
IN ONE AREA AFTER
ANOTHER, WE
PARTED COMPANY
WITH NATURE.

————

# BRING NATURE BACK TO OUR IMMEDIATE SURROUNDINGS

This absence of nature in our lives didn't happen by chance. Little by little, in one area after another, we parted company with nature—we were the first species on earth to have done such a thing. It was a deliberate and conscious decision, because we discovered that it brought many advantages with it.

For most people today there is no alternative to the urban lifestyle, and despite the drawbacks, both those we recognize and those we simply sense, most of us accept the choice without hesitation. The urban lifestyle has been a success all over the world. But what researchers are seeing now is that many of the rising curves that display humanity's progress—life expectancy, quality of life, health—are flattening out. We're experiencing a sort of pause for thought.

We suffer new kinds of afflictions. Fatigue, stress, and respiratory problems are now commonplace in the Western

**WE'RE EXPERIENCING A SORT OF PAUSE FOR THOUGHT.**

———

world. What can we do about it? One solution is to bring nature back into our immediate surroundings.

Research shows that plants and the correct lighting indoors can greatly improve our health, whether it be at home, at work, or in institutions like schools and hospitals. I might possibly, *possibly,* have managed to convince you that it could be a good idea to follow my advice and bring the forest indoors with you. But wait just a few moments before you get going.

## NOT JUST ANY PLANT!

If you've already rushed out to a garden center and paid hundreds of dollars, you will be disappointed. The plants you buy at most garden shops won't give you the effects we're looking for, unless you get the watering and lighting 100 percent right. These plants are cultivated to look their best just at the moment of sale. And usually you won't manage to keep them looking like that for long. In chapter 7, I'll explain some of the reasons for this.

The particular plant I'm recommending, which I also describe in chapter 7, has advantages that make it worthwhile to take the trouble to purchase and care for it. This common, everyday sort of houseplant will work perfectly for you, as they did in the experiments I described in earlier chapters, because this plant thrives on a very simple and straightforward plan of plant care.

**THE PLANTS IN GARDEN SHOPS ARE CULTIVATED TO LOOK THEIR BEST JUST AT THE MOMENT OF SALE.**

First, let's dip into what plants do for us—and what we do for plants.

## A HUMAN-PLANT ECOSYSTEM

Ecology is the science of connections and reciprocity in nature. There are a couple of connections that are of special importance for our particular area. To recap an earlier chapter, NASA's 1989 Clean Air Study showed that plants could reduce the level of harmful chemical elements in the air indoors. The biochemist and microbiologist Dr. Bill Wolverton showed how roots, stems, and leaves worked together with microorganisms in the earth around the plant's root system. They created a mini-ecosystem!

And into that little ecosystem we provide a . . . well, rather dubious type of nutrition for the plants.

## PLANTS AND TOXINS

Dr. Wolverton and his team placed their plants in sealed growing environments containing high concentrations of chemical substances. Among the substances were formaldehyde, benzine, trichloroethylene, carbon monoxide, and nitrogen oxide compounds. These were not chosen at random—they are among the most common pollutants we are exposed to in our urban environments, from lacquer,

paint solvents, machines, and the combustion of coal and oil. When, after a period of time, they tested the air in the sealed environments, they found that the concentration of these substances was lower than at the start of the experiment.

The plants removed some of the worst toxins present in the air we breathe daily.

Yes, Dr. Wolverton demonstrated that common, everyday houseplants that people keep in living rooms, on windowsills, and on office shelves absorb some of the most harmful toxins that surround us in our everyday environments. It's a fact that streets, offices, homes, schools, and institutions are full of these substances. But now we have a means of getting rid of them, or at least of reducing them, in rooms that we use daily. Incredibly, even air-conditioned rooms can benefit, although the recirculation of air will counteract some of the effect.

But those are for extreme circumstances, you might say, when dangerous amounts of these compounds are present. What about under normal circumstances? Further experiments carried out in Germany and Australia confirm that this reduction of harmful toxins is present even where the concentration of substances is around the low levels we experience daily. As long as the plant is healthy and growing (and I'll explain why that is important), it adapts itself to the atmosphere around it and absorbs the toxins accordingly.

*The plants removed some of the worst toxins present in the air we breathe daily.*

*Important info*

"

Common, everyday houseplants that people keep in living rooms, on windowsills, and on office shelves absorb some of the most harmful toxins that surround us in our everyday environments.

"

## GET CLOSE TO A PLANT . . .

Official recommendations set minimum standards for the concentration of a harmful substance in the environment. That doesn't mean that when you feel fatigued or head-achy your body is making it up. *Even low levels of toxins in the environment are noticeable to humans.* We feel better when the amount of harmful substances is reduced, even though these are at a level well below the recommended minimum values.

Incredible, isn't it? Experts tell us the levels are insignificant, but our bodies are getting it right. Our bodies are capable of sensing and reacting to pollution at levels well below those that the authorities and ven-tilation technicians find it worth taking the trouble of measuring. Every man-made item around us emits gases and particles that are hostile to our bodies. But as long as the plants around us are healthy and growing, they attract these toxic elements with the help of the microorganisms around their roots and transform them into nutrition that improves their growth, and the air we breathe is enriched with elements that our bodies instinctively recognize as confirmation that we are in a safe, healthy place. Essen-tially, the plants create forest air. And the more plants, the better. As long as they are growing and healthy!

We feel better when the amount of harmful substances is reduced.

*Important info*

"

Essentially,
the plants create forest air.
And the more plants,
the better.

"

Exuding water vapor, plants also elevate the humidity slightly in a room. This might be the reason why results from the tests in Norwegian workplaces showed a decline in participants' respiratory problems. Especially near computers and electric ovens, where the levels of dust can be high and there are many charged microparticles because of the static, plants can make a significant difference. Don't be afraid to place a potted plant right next to you! The closer we are to plants, the stronger the effect.

## THE CLOSER WE ARE TO PLANTS, THE STRONGER THE EFFECT.

In fact, look around your workplace and chances are you'll see a coworker with a green plant on a shelf beside his or her desk. Research carried out in 2001 showed that plants on desks had a significant impact on the well-being and efficiency of workers who spent more than four hours daily close to computers and other electronic apparatuses.[8] So that coworker of yours? She's on to something.

## . . . OR JUST TAKE A SELFIE WITH ONE

Just seeing an image of green, growing things has a psychological effect. A study on stress at American universities had two groups watch an emotionally disturbing film (in this case about an accident in a workplace). Researchers recorded participants' blood pressure and muscular tension; the result showed that the members of the research group calmed down more quickly when they watched a film featuring a lush, green landscape afterward. The control group, which was shown footage of a barren cityscape afterward, took longer to regain their equilibrium.

## THE BEST MEDICINE

When a patient in the hospital is very ill or recovering from an operation, there is nothing he or she wants more than to get better and go home quickly. Green, growing plants–even just a picture of them–are like a special tonic. In a study carried out by the Swedish researcher Roger S. Ulrich, postoperational patients who had a view of something green and growing needed fewer days in the hospital bed to recover *and* fewer painkillers, and experienced fewer complications such as dizziness and headaches than those whose only view was, for example, of a wall.

"

The sight of plants
seems to helps
the patient recover
more quickly.

"

Read those results one more time. I had to. I couldn't believe it at first. Think about it: What has a postoperative patient been through? He or she has been literally cut open—yet the sight of plants seems to helps the patient recover more quickly. Does this really mean that the mere sight of plants helps people heal better from surgery?

Let me put it like this: If I wanted to make absolutely certain that people would *not* believe what I'm writing in this book, then I think a claim like that would come high on the list of things I ought to leave out. But the claim isn't mine. It's made in a scientific article published from the University of Portland in 1992.[9] And it's not the only study that makes this same claim.

Our Stone Age ancestor would just shrug and ask, "Why on earth are you astonished?" The architect Warne got it right: Build for the plants and the humans will thrive. If we exclude plants from our homes and work spaces, the results are not good.

## PLANTS THAT REALIZE THEIR POTENTIAL

If we're going to move nature into our homes using the Forest Air method, we have to consider health risks. Our health and security were the main reasons we withdrew into our hideaways, which became like "medicine": They sustained our ancestors' health when they moved away from nature to live in larger groups and needed protection from nature and from other people. The move paid off; we

BUT NOW THIS "MEDICINE" HAS STARTED TO MAKE US ILL, AND IT'S TIME TO RETHINK OUR HOMES AND PLACES OF WORK.

lived longer and suffered fewer illnesses. But now this "medicine" has started to make us ill, and it's time to rethink our homes and places of work. But we have to go about this in the right way.

The last thing you want is to bring these dangers back into your life by accident. Grabbing any potted plant from your local florist could bring with it snails' eggs, mold, any amount of exotic little creepy-crawlies, and traces of chemical spray. To avoid unpleasant surprises, it's important to control the process, from the selection of the plants to their care. It's also important to select plants that are guaranteed to grow—and grow as much as possible. (While I'm not talking about growing the equivalent of a prize pumpkin, lush growth is a sign of health. In any case, the amount of soil at your disposal is limited, so the plant won't grow to the size of a tree.) Size will also be controlled by pruning the plant, which also serves to stimulate the plant's defenses. Our aim is to grow plants that achieve their potential: constantly developing and in good health. Only then can they do the job we want them to do.

Our aim is to grow plants that achieve their potential: constantly developing and in good health.

*Important info*

## CORRECTING A FEW MISCONCEPTIONS

Growing, vital plants produce oxygen as a by-product of photosynthesis. A little more than 20 percent of the air we breathe consists of oxygen. If you've

ever dreamed of just closing the doors and windows on the outside world and living a self-sufficient life on home-produced oxygen from your own plants, you're not alone. During the 1960s and '70s, while preparing for humans living in space for long periods, both Russian and American researchers carried out experiments aimed at humans surviving in greenhouses on space stations, the moon, or other planets. NASA's Biosphere 2 in Arizona involved a closed system in which plants, animals, and humans were to live without an external supply of oxygen. Eight people moved into an airtight greenhouse 3.14 acres in size and lived there from 1991 to 1993. (The next year, 1994, also saw a brief mission there.) Maintaining the necessary level of oxygen proved too difficult, and finally liquid oxygen had to be trucked in.

In actuality, the area required to produce enough oxygen to sustain one person is about the size of four or five soccer fields covered in dense vegetation. In other words, unless you live in a mansion that size or own a large plot of land on which you can erect a glass dome, becoming oxygen self-sufficient is going to be a difficult business.

Some people fret about going to bed, turning out the lights, and being surrounded by plants emitting carbon dioxide, as plants in darkness do not undergo photosynthesis, which produces oxygen. Some plant books actually recommend that you don't keep plants in the bedroom because they might use up the oxygen in the air and replace it with

carbon dioxide and so affect the quality of your sleep. Night and day, plants actually do emit carbon dioxide during a process called respiration, but the amounts are negligible, especially during photosynthesis. Carbon dioxide is an odorless, colorless gas that is a natural component of the air we breathe. It also has an image problem, since it's one of the gases responsible for the greenhouse effect. But $CO_2$ is a necessary part of the cycle of nature, a precondition for the maintenance of life on earth—though in recent times the amount of carbon dioxide in the earth's atmosphere has increased as a result of human activity, with one of the effects being possible climate change. In any case, this has no significance for you as a user of Forest Air. Your Forest Air wall cannot raise the level of carbon dioxide in the air either in your home or in the atmosphere in any measurable way.

So set up your plant wall wherever you like, even if, as for so many people in the modern world, your living room is also your bedroom. And sleep tight.

Compared to the five soccer fields that are needed to provide you with oxygen, it becomes even more remarkable that humble houseplants and a simple lighting arrangement would have such a powerful effect. The number of plants and the amount of lighting you will install on your indoor wall are so modest, how can any effect be at all noticeable? The explanation lies in something I call biological logic.

A MERE PHOTOGRAPH OF FOREST BATHING WAS ENOUGH TO LOWER THE BLOOD PRESSURE OF THE SUBJECT GROUP.

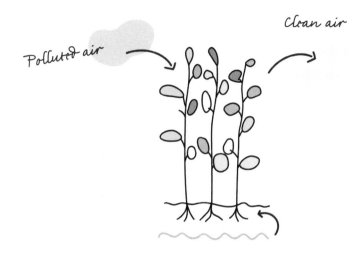

Polluted air

Clean air

## SOMETHING SMALL LEADS
## TO SOMETHING BIG

In biology the most powerful forces do not always create the greatest effect. When one changes a living biological system, the reaction is by no means a predictable conclusion. Biological systems are complex. Very small changes can have far-reaching effects, not necessarily directly, but through processes set in motion. The Japanese researchers who studied forest bathing made a similar discovery: A mere photograph of forest bathing was enough to lower the blood pressure of the subject group.

I believe a similar kind of spin-off effect occurs when we install living plants and correct lighting in the way I'm

"

The effect of the
Forest Air plant wall
can be encapsulated
in the phrase
'Something very small
leads to something
very big.'

"

going to show you. At first glance the following might not seem very impressive:

- We use light from a couple of light bulbs.
- We include twenty to forty small plants.
- We use about 1½ cubic feet of soil.

It seems so little, but the effects from light bulbs, plants, and soil are experienced strongly by research subjects, and they are statistically significant, especially bearing in mind our ability to measure tiny changes in our environment.

In other words, the effect of the Forest Air plant wall can be encapsulated in the phrase "Something very small leads to something very big." It is probably easier to sum up what we in turn do for the plants, because that is quite tangible and concrete.

## GOOD PLANT PARENTING

Ecology is about reciprocity. What part do we humans play in the Forest Air method? In the first place, we act as parents to our plants. We provide them with soil, we water them, and we turn the sun (the light) on and off. This is done routinely and predictably, so that the plant can use its resources in the most sensible way. Perhaps, like parents do, we even wonder what the plants will be like

when they're bigger and worry a little about how they're going to manage.

At the same time, like good parents, we know that children who never encounter challenges will not develop the qualities necessary to get on in the world. Which means that one of our parental duties is to give a child something to wrestle with. By pruning plants at regular intervals, we imitate natural enemies such as grazing animals and strong winds. The effect of this is that the plant realizes the harsh but useful truth that the world is not a consistently secure environment. This stimulates its defense mechanisms and autoimmune system, making the plant stronger and healthier and promoting growth in several areas. It also activates the microorganisms in the soil between the roots, changing the composition of the substances in the soil. In this way new strength is acquired, and how we notice this is that it absorbs more of the substances we want to get rid of.

**WHEN THE PLANT IS HAPPY, WE ARE HAPPY.**

## THE MAGIC LIES IN GROWTH

Growth is crucial to Forest Air, and that is why I am skeptical about utilizing any old houseplants. The fact is, the kind of plant I describe in chapter 7 is best suited for the Forest Air method. Why is this? Because I've worked out how much to water the plants, how much light they need, how much they will grow, and what to do to ensure they thrive. I've arranged everything to keep their care as easy as

possible. These simple instructions are crucial if the Forest Air method is going to work for the plants and for you. They provide the plants with exactly what they need.

> But why is a plant's growth so important? Think again upon our ancestral forebears from the primal forest. Scientific research points to the positive effects associated with a healthy and growing plant. When the plant functions optimally in combination with the earth, only then are the harmful substances absorbed from the surrounding air in the right way–and only then can the plant provide us with the sensation that we are in a place that is good and healthy for us to be. Only a growing plant can give us the psychological confirmation that we have learned is so vital to our health and well-being. When the plant thrives, we thrive too.

Just compare how you feel when you see a plant that is *not* healthy, one that is withering, say. It makes you feel uneasy, perhaps a little unwell. A combination of several sensory impressions will evoke a feeling in you that there's danger lurking somewhere. A withered plant means the environment is dangerous for you too.

How to avoid underwatering or overwatering, or letting the plants get too much or too little light? The Forest Air system is organized in such a way as to eliminate the possibility of anything going wrong—to ensure strong, healthy plants that keep you healthy and strong too.

## THE MYTH OF A GREEN THUMB

A lot of people tell me they don't have a green thumb. Over and over I hear, "I'm guaranteed to kill any plant that gets inside the doorway of my home." I've got some good news.

A so-called green thumb is a myth. There are, however, a few simple rules of thumb to follow.

1. Use organic soil, so that the plant's healthy diet isn't affected by chemical fertilizers.
2. Water the plants properly. Forget about dashing around with the watering can every day—you just need to water every three weeks, period. I'll go into detail in chapter 8.
3. Provide the appropriate amount of light. That means you have to remember to turn it on and you have to remember to turn it off! If you're afraid you might forget, you can buy an automatic timer switch to do the job for you. That's probably the best solution in any case, because it leaves you free to travel for a few days or weeks when you need to. (Actually, plants tolerate having the light on all the time. I'll tell you more about that later.)

And that, basically, is that. Forget about needing green thumbs or some magical talent—this is something everyone can do, and do successfully.

## BALANCED GROWTH IS KEY

Synthetic fertilizers consist of chemically produced nitrogen compounds, which promote rapid growth in a plant, but at a high cost. A plant that grows too quickly might look robust and big, but the plant as a result does not create enough minerals and nutrients for the animals and humans that eventually eat it, nor does it have time to develop its defenses against insects and vermin. It has to be sprayed with protective chemicals in order to bear fruit.

For our purposes, "healthy growth" doesn't mean growing large in size—it's about a balanced development, about thriving. That, by the way, goes for us as well as for the plants.

You've actually seen the Forest Air wall plant that you'll be introduced to in chapter 7 in every home and office. They look unimpressive, but they aren't. Think of them as small computers: simple and smooth on the outside, but with advanced, complicated functions inside. They need a lot more than nitrogen supplements to grow and be strong. The really brilliant thing is that they take care of all these advanced functions themselves. They're in a constant two-way relationship with the soil they're planted in: Bacteria, mold, and microorganisms exchange substances and send signals back and forth, mutually benefiting one another. Researchers have discovered that just one cubic centimeter

"

Researchers have
discovered that just one
cubic centimeter of
the kind of soil we're
using for our plants contains
some eight billion
microorganisms of countless
different types.

"

of the kind of soil we're using for our plants contains some eight billion microorganisms of countless different types.

All this life in the soil isn't anything to be afraid of, although until quite recently anything other than cut flowers were prohibited in Norwegian hospitals because of fears of bacteria in the soil. Rotting flower stalks in vases of water were considered less of a worry—although the nursing staff who had to look after them probably felt those were the greater annoyance. But opinions have changed. Far from showing a higher mold count in the air, the results from Ulleval Hospital revealed that the level actually fell. Microbes in the soil help in one of the important jobs a healthy plant has to do in our home—they break down dangerous gases in the air and transform them into nutrition that makes for healthy growth in the plant.

> And how can we tell, in specific terms, that a plant is healthy and growing well? How do we know that we have followed those green rules of thumb closely enough? Think of what you look for in a salad bowl-leaves with a strong color that are supple and shiny. But we don't just use our eyes: As the research I mentioned earlier shows, we can smell the emissions given off by a healthy plant, even those that are barely measurable, and we sense that the air around the plants is fresher and contains less dust and fewer noxious gases. Moisture circulates throughout a healthy plant because the water it uses to move the substances around inside its own organism is released as vapor through the leaves.

It is hard to say exactly what is most important in creating good growth in a plant. We can't isolate one element or the other and say that this is the most crucial. When a plant is healthy and growing, a number of processes are going on at the same time. I can say that constant communication between microorganisms and the plants, and between the microorganisms themselves, is what leads to good growth.

The sight of the plants and the light, the experience of growth, and the close proximity to these has a deeply calming effect on us.

*Important info*

## SETTING IT IN MOTION

Of course what is most important for us as living beings is not something that happens in a plant pot indoors. The crucial biological processes happen outdoors, outside the walls of our homes and our places of work. This is where we have our five soccer fields' worth of oxygen to breathe, where the food we eat comes from, where the water that is so essential to the life processes of all living beings circulates. Compared to what happens outside at the macro level, the small changes we are able to bring about indoors appear almost insignificant.

But as we saw in chapter 4, there are indeed significant health benefits to be gained from these small adjustments. Even though these changes are on the micro level, their effects are large in scale. There is no simple answer to why plants and light work so well for people, and just how

the combination of natural elements affects us. A great many processes are in operation simultaneously, involving all the senses.

And what we can say is that the sight of the plants and the light, the experience of growth, and the close proximity to these has a deeply calming effect on us. It's too simplistic to say that something is being transferred directly to us; I find it more accurate to say that positive processes are being set in motion in the body—all of which makes it easier for us to bear the stress of modern life.

Example

## FOR THE FUTURE

Imagine that you are sitting at work crunching numbers for a presentation or in your living room scrolling through a news feed. Unbeknownst to you at first, your body registers the presence of a solvent in the air. It might be well below the officially acceptable level, but you start to not feel well. You have the impulse to leave the room, but your old friend willpower refuses, perhaps because you want to be sensible and not hysterical, perhaps simply because this is somewhere you *have* to be. You want to open a window, but the air-conditioning is supposed to take care of all that. So you pull yourself together and put up with not feeling well. Are there long-term health effects that stem from situations like this?

The body is able to tolerate raised values for many of these toxic compounds over short periods, especially when the levels are relatively low; but what happens when you dismiss the body's warnings time and again, perhaps throughout a lifetime? It's too early for research to give us a definitive answer on this; in my view it's for us to worry about future generations and about our own health later on in life.

Green plants have been on the earth longer than we have. By the time humans appeared on the planet, plants had already been flourishing in forests, on plains, and in swamps for more than a hundred million years. We can't imagine a life without plants. In a manner of speaking, they stood around the cradle when we were infants, they produce the oxygen we breathe, and they are a precondition for life on earth as we know it. It's about time we got back in touch with them again.

**IT'S ABOUT TIME WE GOT BACK IN TOUCH WITH THEM AGAIN.**

———

"

Green plants
have been on the earth
longer than we have.
By the time humans appeared
on the planet, plants had
already been flourishing
for more than a
hundred million years.

"

# CHAPTER 6

IN ANOTHER LIGHT

OUR MODERN BUILDINGS
HAVE MADE IT POSSIBLE
FOR US TO LIVE A LONGER,
MORE RELAXED, AND
MORE PREDICTABLE LIFE.

# OUR MODERN BUILDINGS

Light is integral to the Forest Air method. During our ancestors' hunter-gatherer phase, living under the open skies, they got all the sunlight they needed, a vital, full-spectrum light that promoted healthy growth.

As our ancestors evolved and began to build shelters, these structures protected them from the elements (including too much sun) and allowed them to rest in a secure place before heading out to hunt or gather again. Our modern buildings, with air-conditioning and heating, earthquake-proof foundations and storm protections, have made it possible for us to live a longer, more relaxed, and more predictable life. But these buildings present challenges for us.

Dwellings the world over are built to solve problems arising from temperature, wind conditions, and precipitation. On the southern shores of Sicily, for example,

**UNDER THE OPEN SKIES, THEY GOT ALL THE SUNLIGHT THEY NEEDED**

———

people don't need radiant heating to melt the ice on the garden path in winter, nor do they need to reinforce a roof against heavy snowfall. But they certainly need to build houses with thick walls and small windows to counter the sun's heat. Likewise, a homeowner in a rainy Norwegian town would invest in thermal solutions to prevent heat loss rather than in protection from the sun's rays.

Each environment presents its own architectural challenges. Those living in the Southern Hemisphere endeavor to keep out the light and heat, while northern Europeans try to admit as much light as they can. In both cases there are risks of unintended side effects. During the interwar years in Germany the influential Bauhaus school of design produced what it hoped would be a productive, functional work environment for students. The workshop wing of Dessau High School featured an innovative design with enormous floor-to-ceiling windows over three floors. The intention was good—to ensure good light and a healthy environment—but very soon the workshop wing had acquired the nickname "the sweat box." During the summer there was so much light that the building overheated. In other parts of the world, where the sun is fiercely present the whole year round, an indoor culture and strict dress codes can lead to vitamin D deficiency from lack of exposure to sunlight.

## GETTING EXACTLY THE RIGHT, HEALTHY AMOUNT OF SUNLIGHT

## THE GOLDILOCKS PROBLEM

Humans instinctively respond to sunlight. We seek shade if the heat of the sun gets too strong and the warmth of the sun when we are too cold. Humans must also respect the sun. Accomplishing a job that is difficult or demands great precision in the heat of the sun can be as problematic as trying to do that job in the middle of a snowstorm. Even the native Greenlanders had to protect themselves with specially made goggles in the summer to avoid being dazzled or even blinded by sunlight reflected by the snow. Dehydration, sunstroke, sunburn, and even skin cancer . . . as much as sunlight is beneficial, it's dangerous as well.

Getting exactly the right, healthy amount of sunlight is a little like Goldilocks tasting porridge from the bowls of the three bears: Close to the equator, there is too much sun—people have to protect themselves from it. Farther from the equator, such as in Norway, there is never enough sun—people invite it in. Eventually it will hardly matter what part of the world you live in. With people spending so much of their days indoors, the amount of light you would be exposed to in the course of a day will, in practice, be the same whether you live in Norway, New York, or southern Italy.

Sunlight's physical properties have probably not changed since the time our forefathers lived in the African rain forests. The sun's electromagnetic

radiation appears completely white, but when it's broken up into individual wavelengths, such as when sunlight is refracted through drops of water to form a rainbow, we see it's composed of a whole spectrum of colors. Originally only seven colors–an important number in Greek cosmology that carried over into Sir Isaac Newton's research–were identified: red, orange, yellow, green, blue, indigo, and violet. Then scientists discovered radiations invisible to the naked eye, like infrared (IR, beyond the red part of the spectrum) and ultraviolet light (UV, beyond the violet part). Infrared light is the same as heat radiation (what we feel on our skin from a stove or a heater). Ultraviolet rays are what give us a suntan and they can harm our skin if we get too much of them. But UV rays also help our bodies create vitamin D, which contributes to a number of important processes in our organism. Vitamin D is so important that getting too little of it leads to deficiency illnesses, like rickets.

## THE WHOLE SPECTRUM

The light you will be using for your Forest Air plant wall is called full-spectrum light, which closely resembles sunlight. Of course, these full-spectrum lights don't have the same heat as the sun—that would be quite intolerable! Full-spectrum lights have the same light temperature and the highest possible luminosity at which heat does not develop.

Let me explain. Light temperature is the color of the light and is measured in degrees Kelvin (K). We encounter two light temperatures every day, common indoor lighting and work lighting. The color in one of the old-fashioned light bulbs, which for a long time were the only kind of electric lighting, is about 2700K. It's usually referred to as "warm" light and looks a bit yellowish in color. (I call it "yawning light" because it tends to make me sleepy.) The kind of powerful reading light found in workplaces, in kitchens, on desks, or in reading lamps can reach temperatures of around 3300K. For your plant wall we're going to raise even this a bit. The temperature of the light you're going to use is 5500K. It corresponds to the color of light outdoors on a cloudy day, and to our eyes it will seem white.

## GOOD FOR PLANTS, GOOD FOR US

Plants need a light that has all the colors of the spectrum—or actually, what they need is the energy in the particles of light (the photons). This energy is the motor behind various processes that take place within the plant, notably photosynthesis, in which carbon dioxide from the air and water from the root system are transformed into sugar and oxygen. The better the quality of light the plant gets, the more even and healthy its growth will be.

For your plant wall's artificial light to have this same effect, it needs a color combination that matches the colors of sunlight as much as possible. It won't ever match it

HOSPITALS, RETIREMENT HOMES, AND WORKPLACES POINT TO THE FACT THAT LIGHT THAT'S GOOD FOR PLANTS IS GOOD FOR US TOO.

"

# We are dependent on artificial lighting.

"

perfectly—for example, artificial light does not contain the ultraviolet rays that help the body produce vitamin D. This isn't because manufacturers of these lights believe plants can't tolerate ultraviolet light; it's just not possible yet to make lighting tubes and bulbs with this combination.

Artificial lights at the temperature of 5500K aren't just perfect for the Forest Air plants; even if we only get the kind of light reflected from green plants, it benefits humans. Experiments and trials carried out in hospitals, retirement homes, and workplaces point to the fact that light that's good for plants is good for us too.

## DON'T GET THE BLUES

As soon as the sun begins to set, lights in homes, apartments, stores, along streets, and inside parks flicker on—we are dependent on artificial lighting. Plants in industrial-scale nurseries also depend on artificial lighting, especially in regions where for much of the year it is too cold or too dark to grow food outdoors. But if you've ever seen photographs of these large indoor plantations, you might have noticed that the light appears almost blue. Plants grow more quickly in light from the blue end of the spectrum, and the nursery business exploits this. They also save on electricity by using only the kind of light that is

THE REPLACEMENT FOR THE NATURAL LIGHT IS THE LIGHT REFLECTED FROM GREEN PLANTS.

To get what's best both for you and your plants, you need only one type of light: white light, at a temperature of 5000K or higher.

*Important info*

completely necessary to achieve the kind of growth that's most important to them: the tallest possible plant in the shortest possible time.

If you're thinking that blue light in the living room or at work doesn't sound like a very nice idea, I agree: This is not part of our plan. If an assistant in a flower show tries to persuade you to install something like this in the living room, stand firm and insist that this is not the type of light you want. To get what's best both for you and your plants, you need only one type of light: white light, at a temperature of 5000K or higher. That's the only figure you need to remember.

## WHY NOT TAKE A HIKE INSTEAD?

I might have some explaining to do here. First I talk about how dangerous sunlight is, and then I insist that you take it indoors with you anyway—but by investing in light bulbs that resemble sunlight. Isn't that a bit like using PlayStation to try to get into good shape?

Yes, in a way. The natural solution would be for people to spend as much time as possible out-of-doors in a temperate climate for some twelve to fourteen hours a day before heading back inside and going to bed when it gets dark. And if you are able to live like that then I agree: you've got what you need. You're a lucky person, and the manufacturers of light bulbs have just lost a customer.

"

The natural solution
would be for people
to spend as much time as
possible out-of-doors
in a temperate climate
for some twelve to
fourteen hours a day.

"

But I wrote this book for those who are unable to live idyllic lives like that, whether due to health reasons, work conditions, caregiver responsibilities, or other obligations. Their numbers are increasing.

I'm so insistent on using the right kind of light because we need to regain something we have lost in our development into modern cave dwellers: the light our ancestors saw in the primeval forest, the light that tells us that it is daytime and time to be active.

I recall that old joke I told in the first chapter about the miser, the one who had a rather hopeless method of trying to bring light into his home. I think we can give him one thing at least: As he has made up his mind to fetch light, let him choose from the very top of the range.

## CREATING THE SUN

A mere twenty years ago, bringing the equivalent of the sun's light into our rooms would have been impossible: The light bulb or tube would have been too costly, and the amount of electricity needed would have been out of reach of the general population.

But dramatic developments in the technology of LED lighting have changed all that. LED bulbs have become a reliable light source. They are easy to find, there are plenty of good-quality brands to choose from, and they last a long time. LED bulbs are well suited to the Forest Air wall: They are available in a range of different light temperatures, they give off little heat, and they do not use much electricity. In the home of Alexander, whom we met in chapter 3, the total consumption for a twenty-square-foot plant wall was no more than twenty watts.

So the temperature you're looking for in a bulb is at least 5000 Kelvin. Take note: Not every lighting store or supermarket has these in stock. You'll probably have to ask around or do an internet search. You might have to put up with people trying to persuade you to settle for something else. The lamp itself (remember, it has to be suitable for LED lighting) you can buy online or in a lighting store. Choose a lamp that can be adjusted with a flexible arm or hinged holder, so that you can direct the light on the plants and only on them. I've seen some good results in the homes where lights were attached to the ceiling, so the light they

THE TEMPERATURE YOU'RE LOOKING FOR IN A BULB IS AT LEAST 5000 KELVIN

deliver can slant down across the plants and they don't take up much room. Shop around and see what the lamps look like and how they work before making up your mind.

THE FULL-SPECTRUM LIGHTS WON'T BE CREATING ANYTHING LIKE A BEACH ATMOSPHERE. BUT YOU WILL FEEL MORE RELAXED.

## AN INDOOR BEACH DAY?

No need to get out a beach chair, suntan lotion, and a piña colada! The full-spectrum lights won't be creating anything like a beach atmosphere. What you will notice is this: You will feel more relaxed. You'll notice yourself easing off a bit. (And then anything at all might happen. But that's something we can talk about later.)

The light won't even be directed at you in your armchair. The Forest Air effect comes from light reflected from the plants, so the light must be directed *onto* the plants—not on people, animals, or the tchotchkes on your shelves. Specifically, the light should be confined to the green leaves of the plants. This means you will feel comfortable inside the room, and it means the system will work in the right way.

## THIS IS JUST ANOTHER FORM OF LIGHT THERAPY, RIGHT?

In chapter 3 we met a psychiatrist who suggested light therapy for the poor radiologists in their work cave. Can the Forest Air system be regarded as a form of light therapy?

> I get that question a lot, and I can see why so many people ask it. Used to treat a number of conditions, including jet lag, circadian rhythm abnormalities, seasonal affective disorder, and premenstrual tension, light therapy also uses full-spectrum light. However, unlike the Forest Air method, it is a short-term treatment. Also, when you undergo light therapy, you need to go to a specialized treatment center, where you're exposed to full-spectrum light for a short period.

The Forest Air method utilizes light differently. It isn't like taking a pill, you don't stick your head under a lamp, and you don't sunbathe in the light. Instead, the idea is that the Forest Air wall shines unnoticed in the background while you go about your daily life. So no, I don't consider the Forest Air method to be like light therapy. I prefer to think of it as a way to reestablish a natural state in an ordinary, everyday setting.

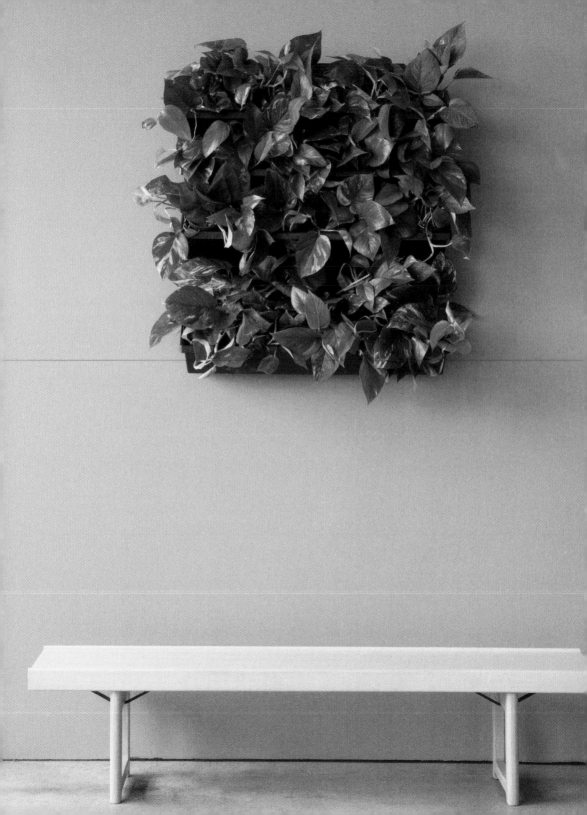

## HOW DANGEROUS IS FULL-SPECTRUM LIGHT?

Some people are afraid that the bright full-spectrum light will prompt headaches or irritate their eyes. I've installed the system in numerous homes and workplaces, and have never yet heard anyone complain of this once the plants and the light were in place. Remember Niels Bjørn Olsen, the preschool head we met in chapter 3? This was what he experienced: "In the beginning we wondered whether we might get headaches, since the light in the plant walls was stronger than we were used to. So after six months we raised this question at a staff meeting. Should we continue with the Forest Air walls? The attendance at the meeting was 100 percent. Everyone voted to carry on with them."

I'm happy to say that headaches and irritated eyes are among the conditions that improve once the Forest Air system is in place. The *only* negative comment came from the night staff at the radiological institute, who felt that the bright light made them feel too wide awake. From their perspective, this is a valid complaint! So if you also work night shifts or otherwise need to take into account your sleeping patterns, take note.

## DAZZLING BY DESIGN

Actually, other people complained about the brightness of the lights; clients who had not yet seen the Forest Air system in use. As in the preschool, once the plant walls were installed, such worries vanished.

We've gotten used to a certain kind of indoor light. It's interesting to realize that we haven't yet adapted to the everyday "yellow" lighting we know from the home and the workplace either. We've gotten used to its light temperature and luminosity, but the effort involved in doing so makes great demands on our brains and eyes, leaving us feeling tired and irritable. For many years this was the only type of lighting available, so we've come to think of it as "ordinary light." We accept it, but our visiting Stone Age ancestor would complain at once. Here's one way to understand what we have gotten used to:

I mentioned luminosity, which is measured by lux. The luminosity outdoors on a sunny day can be between 32,000 and 100,000 lux. The standard for indoor lighting is 500 lux! In my opinion, this figure is due for a revision.

It's amazing what else we have gotten used to! Many a design for a new workplace or home seem based more on the architect's interest in a particular style or aesthetic than on the fact that people will be living and working inside these buildings. The most extreme example I ever encountered was on a tour of a "green" building that was designed to produce more energy than it used. The architect and I entered one of the apartments via a dark corridor in the middle of the building. Far away at the other end of the apartment I saw a pale square of light. It turned out to

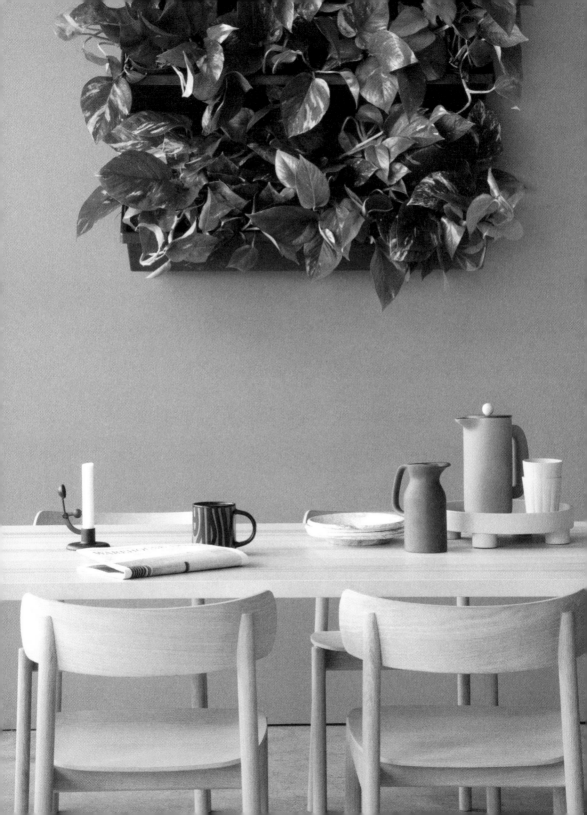

"

The Forest Air method
gives us the feeling of
being out in nature
in the middle of the day.

"

be the only window in the room! The air was terrible, and I asked if we might open the window a little. No, came the reply: "That would be quite superfluous. Air is being exchanged using a balanced form of ventilation to prevent heat loss." I had guessed as much, because I could hear the whirring of the ventilation system. And it was impossible to open the window in any case. I said to the architect, "Don't you think you might have been better employed building a power station?" He thought I was joking. But I wasn't.

Given all the demands made of modern buildings, it isn't easy to satisfy everyone. Meanness of spirit isn't the reason apartments and workplaces are getting steadily narrower and the air and lighting poorer. But it's important to understand that all the efforts made to conserve energy, save money, and facilitate maintenance have consequences for our health and well-being.

## NIGHT AND DAY

Does all this stuff stay on all day and all night? The answer is yes, and the answer is no. The first answer comes from the plants. The second comes from humans. The Forest Air method gives us the feeling of being out in nature in the middle of the day, even though we are indoors grading papers, putting together widgets on an assembly line, or doing a load of laundry. But at some point, as noted by the radiologists, we need to turn off the lights and prepare for

bed. As far as the plants are concerned, the light can stay on around the clock. It doesn't seem to bother them, judging from the many spaces I've equipped—the radiology rooms, the transport terminals, the cavernous halls, and other places where people work twenty-four hours a day. To us, 5000K-plus light seems powerfully bright, but to plants, it is barely sufficient. The luminosity (the lux value) that nature has calibrated them for is far beyond what our ordinary lights can handle. So they cheerfully accept all the light we can give them. The only stipulation is that it mustn't be too hot, or else the leaves will dry up. So the answer from the plants is "As much light as possible, please."

For a human being who goes to bed at night and has to get up in the morning, the answer will be rather different.

Our ancestors in the primeval African forests had a daily rhythm that followed a fairly simple pattern. The day lasted between twelve and fourteen hours, after which it became dark, they grew tired, and in due course they fell asleep. When the rays of sun penetrated the canopy of treetops the next morning, the light stimulated the ganglion cells in their eyes, the melatonin stopped flowing, and up they jumped, wide awake. Contrast that to a modern daily rhythm, where much of the time we are indoors and use artificial light—not to mention with incorrect color and low luminosity. We just can't expect our daily rhythms to function in quite the same smooth fashion.

"

The Forest Air system
will give a more
wide-awake feeling
to your day,
as well as reduce stress.

"

Installed properly, the Forest Air system will give a more wide-awake feeling to your day, as well as reduce stress. Its full-spectrum light gives you the feeling that it really is *proper daytime*. We don't rest very well when it's broad daylight right up until the moment it's time to go to bed, so this light, which feels to us like strong daylight, shouldn't be left on all the time.

I recommend that you turn off the plant lighting well before you go to bed, at least two hours. Give your body a chance to realize that it's evening. I also recommend that you switch the light back on as soon as you rise. An automatic timer can be very useful, giving both you and your plants the perfect illusion of a summer's day—

**WE ARE THE SAME SORT OF BEINGS THAT WANDERED THROUGH THE FOREST IN SEARCH OF FOOD SOME ONE HUNDRED THOUSAND YEARS AGO.**

———

all year round. After waking up, you'll enter the room with your Forest Air plants and at once feel that yes, it is properly daytime. It does the mind and body good to recognize something as essential as our ancestors' experience of day, regardless of what else might be going on in your life.

That is what makes the Forest Air method work. The human body does not adapt to the changing demands of trends and lifestyles. We were, are, and will remain the same sort of beings that wandered through the forest in search of food some one hundred thousand years ago, through a sea of green plants, beneath a canopy of leaves pierced by clear, white light.

# CHAPTER 7

THE HUNT FOR A SUPERHERO–
THE PLANT THAT CAN DO IT ALL

# GIANTS AND DWARFS

From majestic sequoias several thousand years old through wayside flowers to tiny plankton of which up to twenty million can be contained in a single quart of seawater—plant life's sheer variety is amazing. Despite their differences, what all plants have in common are the biological processes that utilize carbon dioxide and water to produce oxygen and create the fuel they need to drive their own life processes. Without plants, life on earth would look completely different.

A peaceful world filled with these green giants and dwarfs, with sunlight filtering through thousands of green leaves, has come to represent paradise for us—and for good reason, as you have seen. Walking through green forests even now, we feel a special calm and contentment, which researchers have been able to quantifiably measure. It is, quite simply, the right place for us to be.

**WALKING THROUGH GREEN FORESTS EVEN NOW, WE FEEL A SPECIAL CALM AND CONTENTMENT.**

## THE STARTING POINT

The typical room in a home, factory, or office usually contains nothing that might make a biological being feel at home. They are constructed along straight lines; they lack variety and light. In surroundings such as these it is no surprise that even the humblest potted plant on a shelf or on a desk is a welcome presence.

When I started working in my field in 1985, the effect of plants in an indoor environment was far from proven, although individual experiments had shown that plants could have a calming effect on humans or introduce health-giving elements into the air. Anyone prepared to spend company money on plants had to possess a high degree of conviction to be able to counter the pressure for cost-effectiveness from accountants and investors. In certain professions it was considered downright comical that anyone would believe little potted plants that a grandmother might grow on her windowsill could improve the everyday quality of working lives.

**IN CERTAIN PROFESSIONS IT WAS CONSIDERED DOWNRIGHT COMICAL THAT ANYONE WOULD BELIEVE LITTLE POTTED PLANTS THAT A GRANDMOTHER MIGHT GROW ON HER WINDOWSILL COULD IMPROVE THE EVERYDAY QUALITY OF WORKING LIVES.**

## KEEPING PLANT MAINTENANCE SIMPLE

I don't know about your grandmother, but the grandmothers of my clients had some very lush windowsills! How did Granny prevent the flowers from withering? Maybe she had a green thumb. Maybe she talked to the plants. I don't favor either theory.

The most important part of Granny's secret was her knowledge: the routine of watering and how to determine the proper amount of light for each plant. For those of you who already care for plants, you soon become well aware which ones tolerate a sunny day on the windowsill and which prefer a little shade; you begin to recognize which ones need a lot of water and which just need to sip.

This knowledge is relatively easy to learn with a plant or two. I had to acquire this knowledge for hundreds of plants we installed and maintained in the workplace. At first it felt like a bit of a jigsaw puzzle to learn about the different types and their specific needs, but eventually I got it. Most important, I learned that a few simple routines could transform a soulless office into a room people looked forward to entering. That was a great discovery.

Right on its heels came the realization that commercial businesses weren't the only ones that needed my help.

**I LEARNED THAT A FEW SIMPLE ROUTINES COULD TRANSFORM A SOULLESS OFFICE INTO A ROOM PEOPLE LOOKED FORWARD TO ENTERING.**

———

## MY TURNING POINT

So you could say that the idea of Granny's windowsill, where the flowers always looked so healthy, was an inspiration for me. It gave me a starting point from which to develop the Forest Air method. Many people would like to have more plants at home, but they worry about keeping them alive. Could I figure out a way to help them? With no stress, no need for magical powers, and no mess?

## PLANTS AREN'T ALL THE SAME

Plants are kind of like people. Some grow quickly, others more slowly. Some are easily satisfied, others more demanding. Some need to be pruned, others are best left in peace.

So running a business utilizing plants has to take this variety into account. This imposed certain practical limitations on us. For example, we could not include in a plant wall a high-maintenance plant that needed attention every day. It would have been incredibly time-consuming, and in addition most workplaces don't appreciate having gardeners running around with watering cans and pruning shears all day. So the plants we used had to be able to survive without my being there for a few days, preferably a few weeks, and without obliging some kindhearted employee to do the watering of the plants in between times. These are the same conditions I wanted to meet in order to persuade people that having a plant wall was something they should have in their own homes.

## THE SPECIAL PLANTS

*Light, water, soil.* These were the three central areas of focus. But something else seemed necessary, even if it was a little difficult for me to define: The plant should exude a kind of vitality. It shouldn't just have life but a wealth of life. The key was *growth*. A plant that grew visibly, almost daily, was crucial in giving back to people a little of the feeling that we have lost in our everyday lives—of being surrounded by something living, of which we are a part, and that enriches our lives.

**LIGHT, WATER, SOIL. THESE WERE THE THREE CENTRAL AREAS OF FOCUS.**

───────

As I watered and pruned in workplaces, I mused and pondered all of the plants I had become familiar with. The plants that seemed to meet these needs best were the kinds that grow close to the ground in the rain forests. I knew that these are plants that do not shed their leaves. Many are epiphytes, or parasites, that grow *on* other plants. Many grow on the forest floor where, by tropical standards, it is relatively dark. Plants like these are able to survive in

a passive state for long periods, becoming active again as soon as conditions improve. Conditions like light, water, and nutrition.

Let's look at light first. Compared with other tropical plants, the plants I was considering had needs that are fairly modest. They make do with a lot less light than their brothers and sisters on the higher levels of the rain forest as they wait patiently for wind, decay, or a rampaging monkey to open a hole in the canopy of leaves through which sunlight can penetrate down to them. They won't have long—within a few days that window for light will be closed again by trees and climbers competing for the precious rays of sunlight—so when that opportunity arises, the plants on the floor of the forest seize it, engaging in high-intensity growth in order to get as much out of the sunlight as possible.

Next, water. Even though the rain forest will almost always be damp, water isn't guaranteed to arrive at regular intervals. This kind of plant finds the water it needs itself, using its roots, having first "sniffed" it out by means of extrusions on the roots, as if "fetching" the water. So this kind of plant doesn't need to be watered often; it can manage by itself for a while.

Third is nutrition, which plants get through the soil. I was looking for a plant that did not need a great deal of soil, since there are limitations of space to bear in mind— no one has a spare acre in his or her home to till. Rain forest plants are outstanding in this regard. With the earth

stratum in the rain forest being thin and poor, the competition for survival at the ground level is a bit grueling. It makes this kind of tropical plant a gold medalist when it comes to getting hold of the nutrients it needs.

And I had a fourth demand: We needed a plant that does not merely survive but grows, seemingly in front of one's eyes.

### REALLY SPECIAL PLANTS

Just as I thought I had zeroed in on some likely plants, in 1989, I read Dr. Bill Wolverton's research results from his experiments with plants in enclosed spaces, which opened

Growing plants
absorb gases in the air
that are toxic to us
and transform them into
elements they use for
their own growth.

*Important info*

up the possibilities again. The plants he had used in his clean air study turned out to have some amazing additional functions. This hadn't been on my radar at all, but now I felt I wanted to include these properties on my list of specifications.

Growing plants absorb gases in the air that are toxic to us and transform them into elements they use for their own growth, and Dr. Wolverton's list contained several plants that scored very highly on this task. The plant with the most toxins on its menu was a member of the chrysanthemum family, *Chrysanthemum morifolium*, closely followed by the peace lily (the *Spathiphyllum* hybrid "Mauna Loa Supreme"). But I had to cross them off my own list of likely plants: Neither of these are particularly robust, so they would need too much care and maintenance.

The plant I was looking for was beginning to seem like a remote dream. But I wasn't ready to give up yet—I went back to Dr. Wolverton's list with another important qualification.

**NO USE WALTZING INTO A SMALL APARTMENT CARRYING A WHOLE TREE.**

## THE ADVANTAGES OF VERTICAL LIVING

Part of convincing people to bring plants into their homes was assuring them that the plants would be compact. (No use waltzing into a small apartment carrying a whole tree.) Most people feel that they have enough stuff as it is, and floor space is always at a premium. But walls, however, are a different matter. A lot of people can make

a wall available just by moving a few pictures around. If I could find a plant that could hang on the wall, that would be the ideal solution. Bananas, bamboo, and poisonous plants from Dr. Wolverton's list were ruled out, as were all ground-growing plants that grow straight upward. A plant that is to grow on a wall needed to be a hanging plant.

One advantage in using hanging plants that grow on walls is that they become part of your world in quite a unique way. If plants are no longer the awkward objects you have to move every time you want to vacuum, you can in many ways simply forget about them and only look at them when it suits you to do so. In reality you'll probably do this quite often, judging by a study carried out at the Norwegian University of Life Sciences in Ås.[10] Participants in the study sat at computers working with spreadsheets, with one group able to look at nearby plants to rest their eyes when needing a break from the long columns. Remarkably, this group scored better than the control group in cognitive tests and in their powers of concentration. Just FYI. . . .

## HOW DIFFICULT CAN IT BE?

I like the attitude of popular Swedish children's book character Pippi Longstocking. When faced with a new task, she says, "I've never tried that before, so I think I should definitely be able to do that."

I LIKE THE ATTITUDE OF POPULAR SWEDISH CHILDREN'S BOOK CHARACTER PIPPI LONGSTOCKING: "I'VE NEVER TRIED THAT BEFORE, SO I THINK I SHOULD DEFINITELY BE ABLE TO DO THAT."

## SO MY TASK WAS TO FIND A RAIN FOREST PLANT THAT:

- can hang
- can survive long periods without watering
- doesn't need much soil
- can tolerate full-spectrum light from a lamp
- grows at a rapid rate
- cleans the air
- doesn't give rise to allergies

I'd never done anything like this before, so I was sure I would definitely be able to do this. And such a plant did indeed exist. It had been there all the time. It originates from the Solomon Islands, once called the "Friendly Islands" by sailors, in the southern Pacific Ocean, and is an epiphytic herb (a kind of parasitic plant) belonging to the arum family. The leaves have dark green and light green stripes, and its name is (I think it deserves its own separate heading):

## BUTTERGRUNT

Only kidding. Its name is:

**GOLDEN POTHOS**
**(Latin: *Epipremnum*** 
***aureum*)**

"I beg your pardon," I hear you say. "Don't I already have one?" You may well, because it's in just about every home, office, and institution. The Forest Air method teaches you how to optimize the growth and vitality of the golden pothos, how to plant it, water it, look after it, and prune it correctly, all to ensure that this humble plant does the job you want it to. And as I've already said, its care—from planting and watering to pruning—is neither difficult nor tiresome.

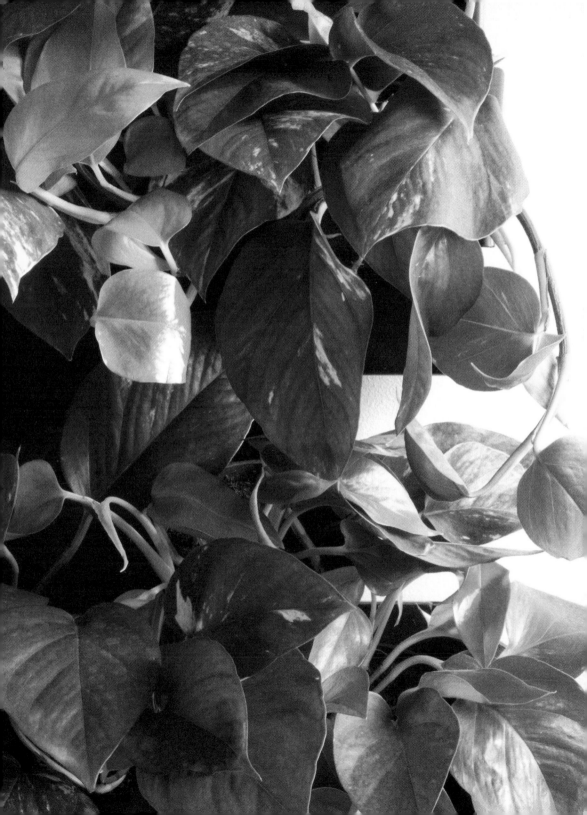

# CHAPTER 8

## FOREST AIR IN PRACTICE

# THE TIME IS HERE

|

You've read this far. You've seen what plants can do for you. You've put up with my jokes. Perhaps you even feel as though you'd actually like to try out the Forest Air method for yourself. Or are you still not sure you can make it work?

## "I'LL NEVER MANAGE THIS!"

Many people would like to have indoor plants, but they think they can't handle the mess—or being responsible for a plant in the first place. They say things like:

1. "I don't have a green thumb. All indoor plants die on me."
2. "I don't want a house full of dirt."
3. "The water gets all over the place."
4. "There's not enough sunlight here."
5. "I always forget to water the plants."
6. "I'm going to make lots of mistakes."
7. "And anyway, I don't have a green thumb."

Let me deal with these worries one by one.

**1. Firstly, this business of needing a green thumb.** I've never seen your hands, so I'm not going to tell you you're lying. But I can tell you something about my own thumbs. They're pretty much the same color as the rest of my body, so mine aren't green either. And yet I manage to look after plants so that they prosper and grow. I've worked out a method that is pretty easy. So I think we need to look elsewhere for reasons why plants don't thrive in your house.

**A GREEN THUMB IS A MYTH.**

**2. About the second worry: "I don't want a house full of dirt."** You won't have one. Apart from the planting, your career as a farmer will be incredibly brief. You don't even need to take the plants out of the pots from the shop. And once the planting is finished, you don't need to take them out of their plant boxes again.

**3. On to the third point: "The water gets all over the place."** The Forest Air method is, above all, practical. The topmost plant box should not be above your reach, so you can easily add water without it splashing over the edge of the boxes.

**4. "There's not enough sunlight here":** You may be right about this. But the Forest Air method utilizes full-spectrum light that gives your plants exactly the right kind of light: one that shines without scorching or drying up the leaves and is strong enough to promote growth.

**5. What about "I always forget to water the plants"?** Did you know that 90 percent of potted plants die because they get *too much* water, not too little? Your plant wall should be watered every third week. It seems reasonable to remember this, but I admit that I too have forgotten tasks. For that reason I jot down a reminder to myself on the calendar or set an alarm on my phone for "Watering Day" at three-week intervals, as far ahead as you can.

**6. "I'm going to make lots of mistakes."** I hear that from a number of people. That is why I refined the Forest Air method to just a couple of simple rules. When should you water? Every third week. When should you prune the plant? When it gets so tall it starts to cast a shadow over the other plants.

**7. And the final objection: "And anyway, I don't have a green thumb."** A green thumb is a myth. Success with plants requires nothing more than following a few rules. I figured out for you the perfect kind of plant for the plant wall, one that is bound to succeed . . . just so long as you follow the guidelines I'm giving you.

## IT'S TOUGH BEING A POTTED PLANT

Actually, the complaint that plants are difficult to maintain isn't so off. Maybe the only things plants really need are water and light, but think about everything a potted plant has been through by the time it reaches your home.

What do you usually get when you buy a potted plant? A greenhouse product grown in a minimal amount of soil, or perhaps with only its roots dangling in nutritionally enriched water. In the course of its short life the plant has known, firstly, a protected atmosphere (artificial fertilizer and violet light) in a greenhouse. It has grown pretty rapidly, because a typical practice is to stimulate plant growth by adding carbon dioxide to the air. Then it has been packed and transported long distances in trucks, trains, or even cargo planes before being placed in a new environment. This might be a windy outdoor section of a garden center or a flower shop crowded with other kinds of plants. When it finally arrives in your home, this poor potted plant is in the middle of at least its fourth life, and has a desperate need for calm surroundings and the appropriate amount of water and lighting.

Think about how *you* might feel after you fly to a different city, have a long layover, take an airport shuttle to another plane, and then fly to another airport and then take

a taxi to your hotel. I'd be completely exhausted, but even then I know what to do. I get something to eat and drink, get my room key, and dive straight into bed.

The distressed, exhausted potted plant can only express its displeasure by drooping its leaves, and by then it might already be too late. Learning what its optimal temperature might be, how much water it might need, and what kind of lighting would be best *might* help it at least survive a few more days or weeks. And you will get advice from many different directions. *Plenty* of advice. You'll get different answers from the shop, from a book of plants, from the internet, or from friends. The advice is almost always complicated and often involves a combination of overfertilization and overwatering, which in the end means either you or the plant will just give up.

**THE ODDS AREN'T IN YOUR FAVOR.**

### "AM I REALLY USELESS?"

Some people will blame the florist. That's probably unfair. Like other businesses, florists thrive on the goodwill of customers. But the flower market, like all other markets, is exposed to the vagaries of fashion, with new products constantly cropping up, trending, disappearing. So it's impossible for florists to give proper advice for all the varieties and hybrids that they might sell. Plants aren't supposed to wither the day after they arrive in the store, but they aren't expected to live for years either. "Buy and hope" seems to be the motto.

So there's no reason to feel a failure when you consign the third potted plant in a month to the trash can. *The odds aren't in your favor.*

This is precisely why I created a system that isn't confusing and is easy to implement. You don't need a lot of equipment or have to read a lot of pamphlets. Taking care of plants shouldn't be like a daily exam or an IQ test. It's the result that counts, and the result should be easy to achieve. Your plants shouldn't plague you like spoiled children. They should be an almost invisible part of your ordinary day. Ideally they should keep to themselves in the background, so that you only notice them—and miss them—if they're not there. (On the other hand you certainly will miss them if you ever find yourself stranded in a room where there are no natural elements present at all.)

## "OKAY. YOU'VE CONVINCED ME. WHAT DO I DO?"

So you're with me? Great, then let's move on to the practical side of things. What do you need to make this work?

The idea is that your plant wall should be so fertile that's it's difficult to see where one plant begins and another one ends. It should look like a single manifestation of living nature.

To get it looking like this, we need about twenty plants, placed so that there are four horizontal rows and five vertical ones, hung in such a way as to form a rectangle three feet by three feet in size.

## THE PLANTING PROCESS CONSISTS OF THREE STEPS:

- Planting
- Arranging the lighting
- Watering

Later, when the plants have grown and are tall and lush, you'll also learn a bit about

- Pruning

Voilà! That's really all you need to know to get started.

So next let's take a look at the different types of plant walls that are on the market today, and the individual advantages and drawbacks of each of them.

**1. The frame system.** This most common type of vertical garden wall planter, which is also the one I recommend, is very simple to make and use. It consists of a hanging frame fastened to the wall with a couple of screws and four flower boxes that are attached to this frame. Sets like this are available from many different manufacturers and can be bought locally or on the internet. See resources list on page 283.

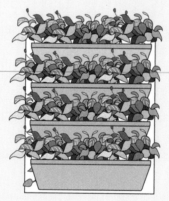

**2. Individual boxes.** You can also buy individual flower boxes for indoor use and screw them onto the wall in a similar way to that described above. Simply buy as many boxes as you're going to need and mount them according to the manufacturer's instructions.

**3. Automatic system.** This third type of plant wall is more advanced. The impressive plant walls at airports, in shopping malls, or in large public buildings are of this type. Plant walls like this are connected to water, electricity, and drainage. You need the skills of a plumber and an electrician for this job, and the wall behind the plant wall needs to be secured against penetration from water and dampness. Parts like pumps and drains will require professional servicing. And you should probably have a chat with your insurance company too—damage caused by water and electricity can be costly to repair.

As you've probably gathered, the third type is not one that I favor for use in the home. With so much involved, there's a danger the plant wall will become a source of stress instead of enjoyment. Would you, for example, dare to travel away from a system in which water is in constant circulation? Could you manage to relax, knowing that a pump failure or a leaking pipe could turn your living room floor into an indoor lake? By contrast, the first alternative on the list is encouragingly simple. The parts are quickly assembled, and they are easy to take apart again should you want to move the installation elsewhere or take it with you when you move. And you don't need a pump or insurance against a damp wall.

So the first option is the choice I'll go with as I move on to show how to create a green wall in your own home.

## SHOPPING LIST

- 1 "frame system" plant wall (see type 1 above)

- 20 golden pothos plants (*Epipremnum aureum*) in 4-inch pots (can be ordered from your local florist or garden center). Note: Adapt the number of pots to fit your chosen plant wall, if dimensions differ from the one in this example.

- Spot lamps for LED bulbs with a type GU10 base that can be fastened to the ceiling. Make sure that you can adjust the direction of the lighting. (A lighting shop will know all about this. Florists and large furniture stores will also help you find the right type.)

- LED light bulbs (full-spectrum), at least 5000K.

- A good-sized watering can, ideally 1 gallon.

# I. MOUNT THE PLANT BOXES TO THE WALL.

**STEP 1:** Attach the frame as directed in the instructions that come with the kit you purchased. Hang the frame on the wall, keeping it as horizontal as possible (use a spirit level if you have one) and being mindful of keeping the frame out of the reach of any pets. If the plant wall isn't hanging straight, the system may not function optimally.

**STEP 2:** Hang the plant boxes from the notches in the frame.

And that's as hard as it gets. Now we're ready to start planting.

Many people live in places where it's either impossible or forbidden to hang things from the walls and ceilings of their apartments. But you can still install a plant wall of the type described. The solution is simple: a shelf–either a "rack" specially designed for plants or a solid bookcase from a furniture store. You may already have one of these. If so, all you need to do is move your trophies and dusty encyclopedias around a bit to make room for your plant boxes. You'll need four boxes (see the first type described on page 218), using one shelf per box.

Try to keep a distance of 7 to 8 inches between the shelves. This is important in creating the dense, lush, rain forest look we're after.

For the lighting you have the choice of a floor lamp that takes LED bulbs, or an LED lamp with a long arm that can be screwed to the top or the side of the shelving. From there, the care of the plants will be exactly the same as the frame type of plant wall.

## 2. PLANTING

Perhaps this is the stage you've been dreading. If you have known many failures in your career as an armchair gardener, then you could be lacking in confidence. The good news is that I've worked everything out ahead of time so you can be successful.

Place the plant pot inside the flower box following the instructions that come with your kit. You do not need to take the plant out of the pot it came in. Each box is made to accommodate a specific number of pots that are to be arranged according to the manufacturer's instructions. This is a quick and easy process.

The installation is that simple. So why not turn it into a meaningful event? Invite family or friends to join you as you create this green change in your home. Having someone to help with the practical tasks gives the occasion a special significance. Together you'll experience a renewed contact with nature and with one another. You won't just be sharing a plant wall but a new perspective on life. For twenty years now I've been getting feedback from people who tell me what a change this has made in their lives. A plant wall is more than an item of furniture: You are inviting the world of nature into your own home.

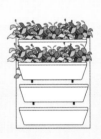

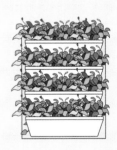

"

Forest Air effect—
earth, light, watering,
and pruning.

"

## 3. LIGHTING

The right lighting is crucial to achieving the full benefits of the Forest Air method.

Attach the lamp to the ceiling above the plant wall following the instructions from the manufacturer. (The process will vary from lamp to lamp, but usually all you'll need is a screwdriver.) Screw the bulb in. Plug in the lamp. (You can also ask an electrician to attach the lamp to the ceiling for you if you're not certain of the correct way to do this.) Switch on the light. Adjust the beam so that most of it is on the plants. The health-giving Forest Air effect from indoor plants arises from the fact that light is reflected from the plants onto you.

And with that, the whole planting process is complete. How long does it take? In my experience the whole ritual, up to and including the installation of the boxes, takes twenty minutes. Worrying about how long it would take probably took longer than that, right?

THE WHOLE RITUAL, UP TO AND INCLUDING THE INSTALLATION OF THE BOXES, TAKES TWENTY MINUTES.

## 4. FIRST WATERING

Your plants have reached their new home after a long journey. There's a temptation to want to give them a hearty welcome and drench them in water. *Don't do it.*

For the most important factors in achieving the Forest Air effect—earth, light, watering, and pruning—to work together, certain rules have to be followed.

But don't worry! The rules are simple. All you have to do is add less than a gallon of water to each box (depending on which type you're using) every third week.

**Once every third week**—*no matter what your instincts tell you, no matter what it says in your plant books, no matter what your friends say, no matter what they tell you down at the garden center.* **Once every third week.**

Repeat after me:

*I will only water every third week.*
*I will **not** water because I "think they need it."*

A handy hint: A lot of people ask if they've done something wrong when the golden pothos leaves turn yellow. Does it mean the plant is dying? Nope. No need to panic. All growing plants get yellow leaves, which are often the lowest leaves on the plant and the oldest. The plant is smart and uses its resources sensibly. Leaves have a certain life span, and when the end of this life span approaches, the plant takes the nutrients back into its roots. The result is that those leaves turn yellow. So when plants are healthy and growing, the appearance of yellow leaves is quite natural. It's a sign of health. By all means remove leaves that have withered, but wait until all the green has "drained" from them–when

the plant has absorbed all the nutrients back into its roots. (The leaves will probably drop off by themselves anyway.)

## 5. GOOD NIGHT

When should I switch off the light? We talked about this briefly in chapter 6. The plants are grateful for any and all light you can give them. But for the sake of the people living in the home, it's best to aim for a regular daily rhythm—for example, light on at seven o'clock in the morning and light off at seven o'clock at night. That schedule will give you an energy injection of clear light in the morning, yet not leave you feeling overly energetic in the evening when it's time to go to bed. Twelve hours is a good amount of time, but really, seven hours or more is fine. You can buy an electronic timer that does the remembering for you, turning the light on and off when it suits you and your needs. If you enjoy a few hours' quiet relaxation in dimmed light in the afternoons and evenings, set your timer to allow for that. But if you were to ask the plants what they prefer, they would ask for as much light as possible.

Whenever we see the green plants, we feel energized. But have you ever wondered why leaves are green? Here's the answer: The plant is able to make use of all the colors in light except green. The light the plant doesn't need is reflected back to us with the familiar and much-loved green hue. Plants already existed on the earth by the time

**WHEN PLANTS ARE HEALTHY AND GROWING, THE APPEARANCE OF YELLOW LEAVES IS QUITE NATURAL.**

we humans appeared, and so it's also deeply calming and affirming for our gaze to rest upon a wall of green in our everyday environment. We know we are at home. With this in mind, it continually amazes me that our culture so emphasizes sterile walls and dwelling places that look like air-raid shelters.

## 6. THREE WEEKS LATER . . . WATERING FOR THE SECOND TIME

In case you're wondering, no, I haven't changed my mind. ~~You should still water only every third week.~~

But you may well not need to water quite as **much** as the previous time. The surrounding temperature and the moisture content of the atmosphere are factors in deciding how much water the plants need.

But how can you tell if you have given them too much water or too little? To find that out, you need a very precise measuring implement: your finger. Stick the index finger of your right hand (or your left hand or, for that matter, whatever finger you would like) down to the bottom of each flower box.

Does it feel dry? Then you can give it the same amount of water as last time.

Does it feel damp? Then give it half a quart less than you did the previous time.

And that's about it, really.

**You still only water every third week.** Never mind what your mother says. Never mind what your best friend tells you he read in a magazine.

I know I've already said this a couple of times, but I don't think I've written it in proper capital letters, have I? Well, then, here goes:

YOU
WATER ONLY
EVERY
THIRD WEEK!

## 7. THREE WEEKS LATER . . . WATERING FOR THE THIRD TIME

So now it's time to water for the third time. And you know what? This time you water *exactly the way you did previously.*

I'm not kidding. You follow the same plan. Because that's what's best for the plants. And because that is the only way to achieve the Forest Air effect.

Check with your finger.

*Is it dry? Give it the same amount of water you did the last time.*

*Is it damp? Give it half a quart less than the previous time.* Carry on.

REGULAR AND CONTROLLED WATERING ARE ABSOLUTELY NECESSARY.

REMEMBER: YOU MUST *NEVER* GIVE YOUR PLANTS AN EXTRA WATERING "JUST TO BE ON THE SAFE SIDE."

If you water more often, you can sabotage the whole system, and make it much more difficult for the plants to adapt. EVERY THIRD WEEK, remember! This is a fundamental principle for achieving the Forest Air effect, and if you don't follow these rules you won't get the results you're looking for.

My thirty years of experience in this field have been good for something! They taught me why so many indoor plants die. The problem is almost always connected to watering, with overwatering being the most common cause, especially where several people share the responsibility of tending the plants. *Regular* and *controlled* watering are **absolutely necessary.**

"

These plants are genetically prepared for challenges of this sort. And not only that— these plants depend on pruning as part of their normal development.

"

Many plants are able to adapt to getting a little water at *regular* intervals, but few are able to adjust to floods, followed by drought, then more floods at *irregular* intervals over a long period.

This is where my method helps you. There's no need to worry about whether you've watered too much or too little. Just follow the "recipe" and water using the same routines every third week.

"But," you ask, "how can I ever remember when I last watered and when to water again?" Mark it down in your calendar—enter it into the calendar on your phone—every third week, for a year in advance if you can.

## 8. PRUNING

This is the part of plant care that a lot of people don't like. What sense does it make to invest a huge effort in getting a plant to grow, only to cut it back down again? What if I cut too much from the plant and it dies?

I can dispose of a few myths surrounding this.

**When you prune as part of the Forest Air method, this is not being mean to the plants. On the contrary, these plants are genetically prepared for challenges of this sort. And not only that—these plants depend on pruning as part of their normal development.** Don't think of it as cutting the plant—think of it as removing the tips of the long shoots before they get too long. This isn't something you do once a year but all year round, as part of our plant care.

The golden pothos you're using should not be allowed to grow too tall. It doesn't grow very tall in its natural state as it's exposed to a great deal more wear and tear in the wild. In fact, in its natural state golden pothos look like the plants you will be growing on your plant wall: bushy, compact, and lush. So you need to indulge in a little persuasion: in order for the plant to understand that it is to its advantage to develop in this way, you need to simulate the kinds of hazards it is exposed to in its natural life—grazing animals, falling trees, powerful gusts of wind.

The pruning itself isn't difficult—simply cut the stalk directly above a leaf joint with an ordinary pair of scissors.

Pruning a plant sends a signal to the root system. The plant realizes that it is perhaps better to develop in a different direction. It produces more shoots closer to the roots, which develop into more compact, lush leaves closer to the soil. That is another reason why proper, even lighting is used: The light is able to penetrate deep down into a

plant's root area so that the leaves that grow there get enough energy to flourish.

When do you prune the golden pothos? A good rule of thumb to follow is that the plants on each row should not shade those below them, and that the bottom row should only be tall enough to hide its box.

You'll have to trust me on this one. Once you've spent some time with your plant wall—sitting in the same room with it, even walking by it on a daily basis, you'll develop a feeling for what's needed. You and your plants will establish a sort of shared rhythm that will make it easier to understand *why* and *how much* you need to prune.

JUST FOLLOW THE RULE OF THUMB. THAT WILL ALWAYS WORK.

I regard this relationship as an important part of the Forest Air method. Understanding nature isn't like pressing a button. It's about establishing contact with the living things around you. Some call it "the old-fashioned way." That's a misnomer. There is nothing old-fashioned about the scientifically demonstrable idea that there is a connection between all living things at the micro level. So if you want to be on the cutting edge, trust your own feelings about what the plants are telling you!

But if this sounds like too much, then, of course, just follow the rule of thumb. That will always work.

## FERTILIZING

Many people ask me whether they should fertilize the plants. Yes, you may, but as I have said already: Overfertilization and overwatering are much more frequent than the opposite. You should fertilize, but only after one year has passed. Then you can use an off-the-shelf plant fertilizer from a florist's or a supermarket, but you need **only one third of the dose recommended on the package.** You can then do this every time you water the plants. So the Forest Air system gets slightly more complicated after the first year, but I have a feeling you will not find it to be terribly hard. And then I would like to add, just as I did about the watering:

**You must never give your plants an extra dose of fertilizer "just to be on the safe side."**

## 9. DOES IT REALLY MATTER THAT MUCH?

When we look at each individual step as outlined, it might seem slightly accidental that it all actually works. Wouldn't an ordinary light bulb do, for example? Can't I water when I feel like it? And why in the world should I cut the leaves off a plant that I paid for?

My standard answers to these questions might perhaps sound a little blunt.

**The Forest Air method is based on years of experience. At all times, my goal was a method with simple rules that**

YOU SHOULD
FERTILIZE,
BUT ONLY AFTER
ONE YEAR
HAS PASSED.

everyone can follow. **With the absolute minimum of fuss and mess.** I didn't want to make plant walls into something exclusive, complicated, or costly, because I don't believe that healthy and natural surroundings ought to be a luxury available only to the few.

**It is important to proceed systematically, because nature isn't just chaos. It has structure.** Every living thing on earth needs a framework within which to function. Some species, like humans, dandelions, and rats, can survive almost anywhere. Others, like our golden pothos, are a little more particular. They don't really ask for all that much, just a little light and water. But if everything is to function optimally, these have to be available in the right quantities and at the right time.

Think about it: Your plants are living in a box with very little earth and their light comes from a lamp instead of the sun. This is in strong contrast to the lives they would lead in the rain forest and the resources they would have access to. We're limiting these plants' ability to manage on their own, which makes it important for us to follow the rules to the letter.

All that might seem a little pedantic. But once you've got your system up and running, you'll forget any little difficulties you had in attaching the boxes to the wall, you'll forget that perhaps you made a bit of a mess with the soil, and you'll forget your irritation at the strict watering rules and the awful anxiety at the prospect of pruning the plants

It is important to proceed systematically, because nature isn't just chaos. It has structure.

*Important info*

for the first time. You'll forget all this, because one day, as you're sitting beside your plant wall, you will find yourself breathing in . . . and breathing out . . . relaxed, composed, energized. And when we allow natural elements to influence us, we might also find ourselves receptive to something new: a more organic understanding of life itself. I'd like to say more about this in the next chapter.

## BUT FIRST: EXTRA! FOR THOSE WHO WANT MORE!

We started with a plant wall consisting of four boxes, and for a lot of people that will be enough. But if you have room for more plants on your wall and would like to make your home even greener, go for it. You can have plant walls in every room in the house if you want.

Plant walls of the box type usually consist of modules about 10 square feet each that you can mount beside, above, or below each other. The only thing you need to be very careful about is that the plants get enough light. Although you can easily mount a new lamp for each new plant module, you'll perhaps reach a point where you have so many lamps that the room looks more like a film studio than a cozy home.

If you do want extra modules, the solution is a single, very strong lamp with enough light to cover the whole plant wall. A light as powerful as this won't be particularly pleasant for you to spend time under,

so it should be combined with a timer that switches off the plant light during periods when people are using the room. At www.skogluft.no you'll find more advice on this. You'll also find helpful hints about where to buy the equipment you need.

As long as there is an uninterrupted eight-hour period during every twenty-four hours when the room is not in use, the plants will get sufficient light to grow and thrive. And in the evening you can still enjoy your green wall—by the ordinary light of the room.

## EXTRA! EXTRA! FOR THOSE WHO WANT AN EVEN CLOSER CONNECTION TO THE EARTH!

Some people might want to use more old-fashioned methods, and of course that's perfectly possible too. These methods are, after all, how I gradually experimented my way toward the supersimple Forest Air system.

This particular system I'm about to describe isn't quite as easy to install, but you might experience a greater satisfaction having done the whole job yourself from start to finish. Nor can I give you the same guarantee with regard to results, but as long as you stick to the same principles governing planting, lighting, and watering, I see no reason why you shouldn't succeed.

First you need to take a shopping trip to a garden center or florist and to a lamp or furniture shop to buy your lighting.

**THE FOREST AIR SYSTEM IS REALLY SIMPLE.**

## SHOPPING LIST
- 1 "frame system" plant wall (type 1), or 4 individual flower boxes (type 2)
- 20 golden pothos plants
- 0.35 cubic feet (10 liters) of clay pebbles for use with plants
- Gardening cloth (enough to cover the base of the pots)
- 1.5 cubic feet (42.5 liters) of *organic* potting soil

- 4 watering pipes, about 8 inches long. Some garden centers sell these, or you can make them yourself, for example using plastic plumber's piping or thick plastic piping for maritime use. The internal diameter should be 1½ inches. At the bottom of each pipe you'll need to place mesh that prevents the pebbles from entering the pipe but that also allows the water to pass through to the bottom of the box. A piece of window screening will do fine. Use plastic strips or gaffer tape to attach it around the bottom lip of the piping.

- An adjustable ceiling lamp of the same type I described earlier (can be bought in a lighting shop or on the internet)
- A large watering can with a long spout, preferably with volume markings

## INSTALLING

- Hang the plant wall or the flower boxes according to the manufacturer's instructions on your kit.
- Place the water pipe at the bottom of the lowest box. Consider ease of access for watering.
- Put in a layer of clay pebbles, to a depth of about 1½ inches.
- Cut or shape the gardening cloth so that it easily covers the pebbles. Tuck it firmly around the water pipe.
- Fill to the top of the pot with earth.
- Repeat the procedure for the next three boxes.
- Done!

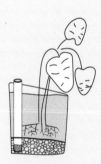

## PLANTING

I've always believed that bare hands are the best tool to use to get a feeling for the earth and how the roots have arranged themselves in the box, but of course you can also use a small planting spade or spoon.

- Dig a hole for the first plant. It will be easiest to space the plants evenly if you dig the middle hole first. Dig right down to the gardening cloth.
- Take the golden pothos out of the plastic flowerpot it came in by squeezing hard on the sides of the pot and lifting the plant with its soil out. It doesn't matter if you lose some of the soil.
- Place the golden pothos in the hole you have just made.
- Pack the soil firmly around the plant. Don't be afraid to press hard. The soil has to be packed tightly to remove air pockets; otherwise the plant will not be encouraged to spread its roots. It's best to use your hands for this job, but if you don't want to dirty your hands you can always use gardening gloves.
- Follow these instructions for the remainder of the plants.

And now you can forget about the soil for a long time. It doesn't need to be taken out again after this.

## WATERING

The most important principle here is to water at regular intervals. You should never give your plants an extra watering "just to be on the safe side." It's also important that watering is only done through the watering pipes that conduct the water down to the clay pebbles in the bottom of the box. The plant itself absorbs the water from below, using its root system. If you water from above, the system won't work.

Watering intervals in this build-it-yourself version are just as important as in the ready-made version: It should be done every third week. Never more frequently.

But, in fact, first you're going to break one of those rules. Before the first watering through the pipes, you're going to "prep" the earth in each box by giving it about 2 quarts of water *from above*. This activates the microorganisms in the soil to give the plants a head start. But that's the first and last time you will water from above.

The first watering is important. *The amount of water* is crucial. That's why you should measure exactly how much you use both on the first and second occasions, and on all subsequent waterings after that.

Start with 4 quarts of water. Not for the whole plant wall, but in each water pipe. So that's 4 quarts per box.

Be precise. Not necessarily to the last drop, but do the best you can.

And when you've done this for all four boxes, you've finished the first watering.

## LIGHTING

Attach the lamp to the ceiling, about three feet away from the wall. Screw in the bulb. Plug the lamp in. Adjust the lamp so that the light falls *only* on the plants. Light reflected back from a white wall has a dazzling effect that makes it uncomfortable to be in the room.

When do you turn off the light in the evening? A rule of thumb is to leave it on from seven o'clock in the morning until seven o'clock in the evening, corresponding to a twelve-hour day. Continuous exposure to light for seven hours per day is enough to make the plant grow. Consider using a timer to ensure that the plants' light needs are always met.

## THREE WEEKS LATER . . .
## THE SECOND WATERING

Now you're going to do a little research. How much water do the plants actually need? You're going to use a very sensitive instrument to measure the amount of moisture—it's called your finger.

Stick the measuring instrument (i.e., your finger) into the soil until you can touch the gardening cloth.

Does the soil at the bottom feel moist? Then you've watered properly. Use the same amount of water this time as you did previously.

Does the soil feel bone dry? Then you haven't watered enough. Use 1 quart more per box than you did previously.

WATERING
SHOULD
BE DONE EVERY
THIRD WEEK.
NEVER MORE
FREQUENTLY.

Does the soil feel drenched? Then you've watered too much. Wait three weeks and then check again.

Don't assume that what one row needs will be the same for all of the rows. There might be a slight difference, especially between the top and bottom row, so check each row that you water.

## THREE WEEKS LATER ... WATERING FOR THE THIRD TIME

Does the soil at the bottom feel slightly damp? Then use the same amount of water as before.

Does the soil feel bone dry? Use an extra half quart of water.

Does the soil feel drenched? Perhaps someone has sneaked in an extra, in-between watering? If so, then wait another three weeks before watering again.

And continue like this. **Remember—always wait three weeks before watering again.**

For pruning we follow the same rules as for the first system: Cut away the shoots that shadow other plants or that hang below the bottom of the pot.

Good luck!

# CHAPTER 9

## CARRYING ON FROM HERE

# WHAT HAPPENS NOW?

|

If you're now considering making a plant wall following the instructions in this book (or already sitting and looking at your finished wall, with plants and lighting), perhaps you're thinking: Is that it? What happens now?

I don't think that's it at all. Forest Air doesn't stop there. There are additional benefits from bringing nature indoors to a place where you spend time every day.

## A GREEN DEVELOPMENT

When I changed careers more than thirty years ago it was because I wanted to work in closer contact with nature. The idea was not to make more money. I knew I didn't want to drop out of society and move to a cabin in the forest, but I did not want to continue as before. I wanted to contribute to the development of society in a different way than I had done so far.

**THERE ARE ADDITIONAL BENEFITS FROM BRINGING NATURE INDOORS.**

Nature was an obvious starting point for me. In 1985, society was, in many ways, much more hostile than today's society toward the ideas of environmental protection and humans' stewardship of nature. Pollution, regarded as an unimportant phenomenon, was not widely used as an argument against industrial development. In fact, affluence and pollution seemed to be two sides of the same coin. The oil industry had enormous power and was able to pressure companies and nations alike to dance to their tune. The pursuit of alternative sources of energy like solar and wind power was considered strictly the province of idiots.

I'm generally a practical person; I like to work on solutions and see results. I appreciated being able to work with plants and was able to see the positive effects of my job every single day. But even though hundreds of employees confirmed the improvement in their lives, it remained difficult to give a precise description of exactly why that was. What was it that made the plants work?

I wanted hard facts, which is why I was so enthusiastic about NASA's research program. Tove Fjeld's studies from Norwegian workplaces were groundbreaking, showing very clearly that plants had made a contribution. Plants and light had clear, positive effects on health that could be demonstrated using scientific methods. It was gratifying to come across research that confirmed what I believed.

And from this a new thought arose: **Why focus just on places of work? What about schools, public institutions,**

**WHY FOCUS JUST ON PLACES OF WORK? WHAT ABOUT SCHOOLS, PUBLIC INSTITUTIONS, AND LIVING SPACES? SURELY THE NEED IN THESE PLACES WAS JUST AS PRESSING?**

and living spaces? **Surely the need in these places was just as pressing?** But adjustments would have to be made. I experimented using different plants for quite some time and managed to find a combination of plants, light, and water that would make it almost impossible to fail. Suddenly a whole new market opened up, one in which organizations and families could look after plants in a way that previously only professionals had been able to.

The health benefits of plants were now available to all!

The health benefits of plants were now available to all!

*Important info*

## PLANTS CHANGE US

Having green plants and natural light around us simply makes it easier to meet life's daily demands—whether in a job or doing housework or homework. Green plants and natural light help us to experience daily life as less stressful and demanding.

But I believe the effect of plants goes even deeper than this. Or I should say: The effect is more *profound*. Might it be that proximity to nature helps to give us a different attitude toward things like family, friendship, career, and society—to relationships, morality, and our own feelings of value? What is the difference between having a living forest in your own room and seeing one on the TV or

computer screen? Does it change our way of looking at other living creatures when we know that the plants in our plant wall are dependent on us for their survival? Many of my customers tell me that it can suddenly seem the other way around: The plants are what ensure *our* survival. And in a biological sense this is quite right. Without plants, none of us would be here.

And might a change in our biological perspective also lead to a change in behavior in other areas of our lives?

**WITHOUT PLANTS, NONE OF US WILL SURVIVE**

## CHANGING OUR VIEW OF THE BOTTOM LINE

Once we experience the impact of contact with living nature—when we experience on a daily basis that our own actions have a decisive effect on whether the living creatures around us live or die—is it still so easy to develop a building site for apartment blocks on a bird sanctuary or on a valuable forested site?

Cost effectiveness is a common argument in favor of developing and exploiting natural resources. But we know what the *real* cost of these projects is. From a biological perspective, the cost is not borne by the firm doing the developing or the mining for resources. It is borne by future generations, who are obliged to live with the results. They are the ones who will do the tidying up. That task can take several decades and cost enormous sums of money. In

addition, the destruction of the natural environment can have serious consequences for public health, which undercuts the argument for cost effectiveness. Most businesses operate with no long-term environmental perspective at all. Resources are exploited with no other concern than short-term profit. Very often there is no plan in place to clean up after the job is done.

That kind of thinking is like someone taking out a loan without having the intention of ever paying it back—essentially putting the burden of repayment on future generations. This kind of growth is contrary to biological growth, which is about change and adaptation aimed at *preserving* life. Growth that merely *consumes* resources will lead us inevitably to self-extinction.

*Important info*

## CHANGING OUR VIEW OF WHAT WE EAT

**As our plant wall develops and grows—flourishing before our eyes—we discover a unique understanding of the complexity of life.** The plants themselves look simple, but there is huge variation from leaf to leaf, from stem to stem. You can never predict exactly what the next leaf is going to look like. Each new leaf will unfurl in a slightly different way from the previous one, but you have no doubt that it is from the same plant.

As our plant wall develops and grows-flourishing-we discover a unique understanding of the complexity of life.

This kind of complexity is fundamental for all life. Without the enormous range of variations possible within each individual species, plants and animals would have no hope of dealing successfully with the challenges they face in the wild.

Industrial farming takes the diametrically opposed attitude. The goal for that industry is to make a flawless product that grows as quickly as possible. As customers we must take our share of the blame for this; market research shows that consumers choose vegetables and fruit that look symmetrical and uniform, even though these qualities do not guarantee a high nutritional content. There are sound economic reasons why farming is carried on in this way. But in my view the demand for cost-efficiency and financial profit have the same effect here as in industry, the building trade, and mining enterprises. Over fertilization, wasteful consumption of water, and the use of pesticides impoverish the soil in the name of food production and harm the surrounding environment. The mass death of insects in Europe over recent decades is a grave warning to us that we are busy sawing off the branch we're sitting on.

Artificial fertilizers cause plants to grow quickly. But this rapid growth also means the plants cannot develop in an optimal way to provide the nutrients we need–they don't have time to reap the benefits of the crucial interplay between the microorganisms in the soil. Maybe a biological understanding will give us a taste for food that has been organically cultivated– closer to our natural nourishment in its content of

**WE ARE BUSY SAWING OFF THE BRANCH WE'RE SITTING ON.**

important nutritional elements, enzymes, vitamins, and minerals. In my view it is very misguided to treat food production separately from the rest of the ecological world. Because we humans are also a part of nature, it's essential that the food we eat is produced in a way that resembles nature's own way as closely as possible. Only then can we be sure it contains the correct balance and combination of elements that we need.

I've heard the objection that these elements are present in such small quantities that they make little practical difference. But what if what is important is not the quantity of these elements but the fact that they are present at all? This very conclusion was borne out in research on plants indoors–the amount of oxygen and active ingredients released was not what mattered. What mattered was that the plants were physically present. The same is true, I conclude, of the microscopic amounts of trace elements, vitamins, salts, and minerals we find in food that has been produced under natural conditions.

## CHANGING OUR VIEW OF RELATIONSHIPS

Most modern rooms seem to be built around the television set. A TV might remain switched on from the moment we come home to the moment we go to bed; it even provides us with the subject of our conversations. (Or perhaps TV actually gets in the way of a good conversation.) What

happens when the plant wall arrives in such a room? Is it possible our own feelings and interests might, instead, move to the foreground?

Television—and by this I also mean streaming shows on laptops and phones—is popular because it satisfies a deep need. We get home and close the door behind us, but we don't want to break off all contact with the rest of the world. TV functions as a kind of window to the world, to use a well-worn but apt cliché. But what sort of world is this, actually? News broadcasts account for only a little of what we watch. The way other people furnish their homes, their wretched personal dramas, along with titillating tales of sickness and the resolution of gory murder investigations, seem to account for most of what we are unable to manage without.

**WHAT IF WE TRIED A NEW WAY OF FURNISHING OUR HOMES? NOT BY REMOVING THE TV SET, BUT BY GIVING THE PLANT WALL AN EQUALLY PROMINENT PLACE?**

**What if we tried a new way of furnishing our homes? Not by removing the TV set, but by giving the plant wall an equally prominent place?** When I've installed plant walls in people's homes, offices, or institutions, I've noticed that these walls arouse great interest. People linger when they should be finishing up reports or in meetings to watch the installation. They're curious, asking all sorts of questions. But then, once the plant walls are up and the installation is complete, I notice a change. The conversations don't end, but instead of looking at me they're gazing at the plant wall. It's clear that a wealth of greenery communicates with us on some level or another—almost as though we look for our answers or confirmations in there.

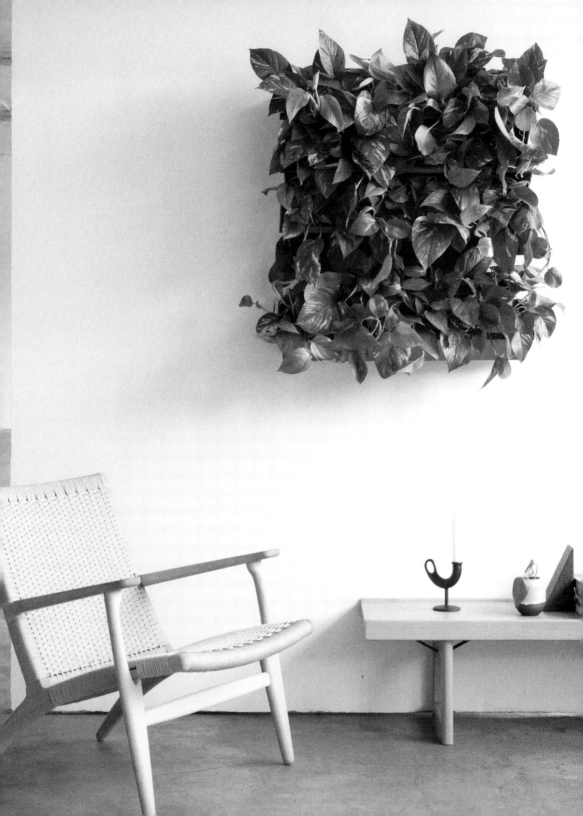

"

Instead of sitting
passively in
front of the TV,
we start to
communicate and do
things together.

"

The way nature affects relationships between children was something I had the pleasure of experiencing firsthand when I threw a birthday party for my son. I, like a lot of people, dreaded the arrival of a gang of lively, excited, and maybe tentative children in a small living room. Instead we headed out into the woods. Each child was given a log to carry, and once we arrived I let the kids run around as they pleased (making sure, of course, that they didn't fall into the water or tumble over a cliff). What did they play? They invented their own games, playing make-believe and acting out parts, climbing trees, playing hide-and-seek. No word from me was needed, not until we dug juices and sodas out of the cooler, lit the fire, and roasted hot dogs. I saw a connection here, between nature's powers of self-organization and the free and natural way those children responded to the experience.

In my years of experience, I've noticed that plant walls lead to similar changes in the conduct of interpersonal relationships in everyday life. Instead of sitting passively in front of the TV, we start to communicate and do things together. In a natural environment, we relax and open up. We learn to listen in a new way and connect with other people on a deeper level—taking part in the conversation with your whole being, with your whole system of values and beliefs.

Caring for a plant wall is an activity that brings parents and children together. I think it encourages a deeper understanding of nature and deepens the relationship between people—adults and children, friends

I THINK IT ENCOURAGES A DEEPER UNDERSTANDING OF NATURE AND DEEPENS THE RELATIONSHIP BETWEEN PEOPLE.

**and lovers, old and young.** In learning about the interplay in nature in a practical way, we also deepen our relationships with one another, learning to concentrate on community and togetherness instead of disappearing into an isolated world of exclusive personal interests.

## CHANGING OUR VIEW OF SOCIETY

Research has shown that green surroundings make us relaxed and lead to an appreciable decrease in stress levels. In developing built environments that incorporate plants, by making the environment around us more plant friendly, we also make them more human friendly.

The last few decades have ushered in a revolution in communication technology, making it possible to "design" businesses, firms, and production lines to meet actual needs. Successful firms of the future will no longer need to be large in scale—it'll be enough to deliver exactly the product or service that meets the requirement of the client at that moment in time. Huge companies with annual profits greater than many national budgets—and often with as much power as a nation—might someday be a thing of the past. When that is the case, developing countries will not feel compelled to shape their societies to suit these large companies' needs. Instead we will move into an era of a multiplicity of microchanges based on changing interests. This is the way nature operates too, enabling each individual species to find its place in the ecosystem.

*Example*

## THE CHANGING TIMES

ACK Architects in Oslo has been an important partner for me. We have collaborated on many projects and enjoyed many more good conversations about what can be done to create healthy environments for people in buildings. ACK's Beret Aspaas and Richard Cooper have their fingers on the pulse of what's happening in the international world of architecture and interior design. They have no doubt that the utilization of natural elements indoors is increasing.

"Almost from the beginning I was fascinated by NASA's research," said Beret. "A great many people now are preoccupied with the benefits of having plants indoors. Now that we spend over 90 percent of our lives indoors, I believe the time really has come to join the two worlds together and explain to people what plants can do for an indoor environment."

Richard added, "When we build, our chief concern is to place people at the center. Our designs start with people. And to do this, we need to understand people and how they work together, and create an environment in which people can thrive. So an indoor green environment can bring about very great changes in the architecture of a building."

What amuses me most of all in my collaborations with Tove Fjeld and the architects at ACK, and often with my customers, is the realization that we had all arrived at the same conclusions from very different starting points, and received confirmation for our ideas from respected research institutions throughout the world. But even though researchers and builders now know a lot more about what is needed for a healthy environment, indoors and out, it's not a foregone conclusion that the cities and suburbs of the future will be built according to these insights.

However, Richard has said that, increasingly, the efficient exploitation of space in public buildings is becoming a priority, and that this tendency will continue to affect public spaces for a long time to come. Beret noticed other developments too. "All the same, it looks as though things may have reached some kind of turning point. It's permissible now to talk about the nonmaterial qualities of a building. These days we're talking a lot more about the senses: Are the acoustics good? Is the lighting good enough? Is the ventilation good enough? There is a lot more focus on such questions now. Our standards and expectations are higher than what they were a generation ago. And this is where 'green' comes in."

So for the indoor species, *Homo sapiens*,

NOW THAT WE SPEND OVER 90 PERCENT OF OUR LIVES INDOORS, I BELIEVE THE TIME HAS COME TO JOIN THE TWO WORLDS TOGETHER.

the news is both good and bad. While economic and material considerations severely restrict the form of buildings, an opposing trend lays greater stress on what are very human needs–the personal, the sensory–and on incorporating nature.

But what do you do if you find yourself in an environment, whether at home or at work, in which no account has been taken of these human needs? I asked the architects if they have any advice about how to make an environment more personal and alive.

"If you live in a very built-up area," advised Richard, "for example, in a high-rise where your only view is into another high-rise, then you need to get something green into the building. You have no control over what goes on the outside, but you can certainly do something about the inside. We're talking about retrofitting. You can do something that simultaneously increases the quality of the light and the greenness of your environment." Richard has a name for this kind of retrofitting: the "light and green package."

Beret said she believed that in the future we will see more of this holistic thinking. "The way forward leads from a passive to an active use of the building. It also means one becomes more aware of the role of the different elements within an indoor environment."

Richard picked up the thread: "Take a fireplace, for example. When you sit indoors gazing into the embers, it's a little like a plant. It's a living element in the house. We see the same thing in a timber wall, in the structure in the timber, or in a marble slab. You can see that these elements of the building have been made from living materials. Things that are either living or have been living have a very special effect when they become part of an indoor environment. They show the same kind of mixture of the arbitrary and the regular and ordered as plants do."

Beret also has ideas about how you can take the weather itself into your home: "If you place a little 'water mirror'–a bowl or basin filled with water–outside the window or on the windowsill, the conditions outside will be reflected to you inside. I think any outside element has the potential to bring poetry into your home–especially if it's something you created yourself. It doesn't have to be much. Put a little stone in a dish of water on your windowsill and suddenly you have a little bit of nature nearby. And if, when you're out walking in the countryside, you see a stone that appeals to you, pick it up and take it home. Put it on your kitchen table and it will remind you of your country walk. Green plants, living things, light, and shade are of great importance."

Example

"As people, we react to change," added Richard. "Things get boring if nothing changes. We need variety."

"And technological changes, important as they are, are not essential for us architects," says Beret. "What's visionary for us is to arrange things in such a way that people feel good."

The conference room at ACK where we had this conversation is white and discreetly furnished. A large white worktable is the central item of furniture. It could be the office of any sort of business, except for the fact that, strewn across the large white desktop are several inspirational objects—pieces of marble and other sorts of stone, seashells, seedpods, and bits of wood, each one unique in appearance and quality, some soft, some hard, some cold, some warm.

I believe the idea behind this little exhibition is a close relative of the ideas I have tried to communicate in this book. Our real world—our real environment—is that mixture of the arbitrary and the regular that we call nature. When we limit out thoughts to the fact that $1 + 1 = 2$, and never see or touch anything other than polished plastic, glass, and steel, we lose sight of something important in our lives. So it makes me happy to see so many experts in so many different fields coming to the same conclusion as I have.

## ONE FINAL THOUGHT

We have traveled far in space and time in this book, from Japan to Western Europe, from the infancy of humankind to our own time. We have met researchers, architects, teachers, business leaders, small children, and elderly grown-ups. Research, historical data, and common sense all point in the same direction: **We have distanced ourselves too far from nature, and the result is suffering and illness.**

For many people, the longing for a simpler life, with plants and natural surroundings, is just a romantic and illusory dream, a fantasy with no connection to reality. Research has shown that this is not the case. A lack of nature is a real problem, and so are its consequences.

But we have also seen how the gradual introduction of natural elements into places where we spend most of our time, and especially indoors, can bring relief from the pressures of our surroundings and remove the causes of many of these health problems.

THE FOREST AIR METHOD GIVES YOU A GOOD METAPHOR FOR THE TYPE OF GROWTH YOU WANT TO SEE IN YOUR OWN LIFE AND IN YOUR RELATIONSHIP WITH OTHERS.

Humankind has not been an indoor species all that long. It has only been about 250 years since the Industrial Revolution led to humans working indoors for most of the day. Along the way there has been a change of attitudes. Those employed in a business or organization have moved from fostering working conditions reminiscent of servitude to offering more: A good wage is no longer enough if a company

wants to attract the best workers in the future;
relationships to others and an ethical involvement in
social issues are of equal importance.

Leaders of industry such as Google's Jan Grønbech report that the educated young of today look beyond a wage structure when applying for a job. They want to share a vision, an idealistic engagement, a social responsibility with their employer.

I think this is good news. Large corporations are moving from being environmental laggards that exert a negative force within society to becoming leading voices for change and development across the globe, based on the realization that what is good for the planet will benefit all of us. Including the big companies.

The term "growth" has become a byword of approval in modern society. But growth in nature is not just about size. This kind of growth is a continual process, one in which new functions and powers are developed to adapt to a constantly changing reality. From this perspective, there can be a great disadvantage to being too big. Those who rise above others are subject to attack from all kinds of living beings and forces of nature, and maintaining a large organism calls for a considerable expenditure of energy and resources. This is worth remembering when we try to promote growth at any cost, with no thought to the energy and the resources required to drive the growth. Instead we should be looking at models that remind us of nature's

"

During the last
two hundred years
we humans have lost sight
of this logic as industry,
transportation, and new
demands have changed our
lives completely.

"

own way of solving problems and dealing with challenges, in which closeness, contact, and common interests build alliances, collaboration, and community.

**The Forest Air method gives you a good metaphor for the type of growth you want to see in your own life and in your relationships with others.** Living plants demand a different kind of care and attention than a blank wall that you scour with cleaning liquids and on which you hang up pictures. **The key word here is *reciprocity*. A plant wall gives something back to you.** What you get might not be as tangible and concrete as what the plant gains when you water and prune it. But the mere fact that it develops alongside you provides a sense of belonging and a calmness that can change you—not only every day, but also in the long-term goals you set for yourself in life.

**There is a logic in all life. I call it a biological logic. This logic is to be found in all living things and has developed over millions of years. During the last two hundred years we humans have lost sight of this logic as industry, transportation, and new demands have changed our lives completely. Slowly we have replaced it with a simple, mechanical model that has suppressed our biological competence.**

This is not something we learn about at school, and it isn't a course option in an economics degree. Yet this is where we find the basis of life. It is this knowledge we need to repossess; we must learn to make use of the power that lies within biological logic. Young people of today have no

THE KEY WORD HERE IS RECIPROCITY. A PLANT WALL GIVES SOMETHING BACK TO YOU.

difficulty in understanding this. For them it is quite natural to unite the mechanical model with biological wisdom.

The most important thing to understand is that we are dependent on one another. To paraphrase Aristotle, a good life must be lived with a good society. It must also be lived within good surroundings. And these surroundings have to be places where we belong. The right living environment is the natural space for a natural life.

I think of this as wisdom, and nothing would make me happier than if you feel the same way after you've read this book.

It all starts with you. Step by step we can bring nature back into our homes and make the world a greener place, one wall at a time.

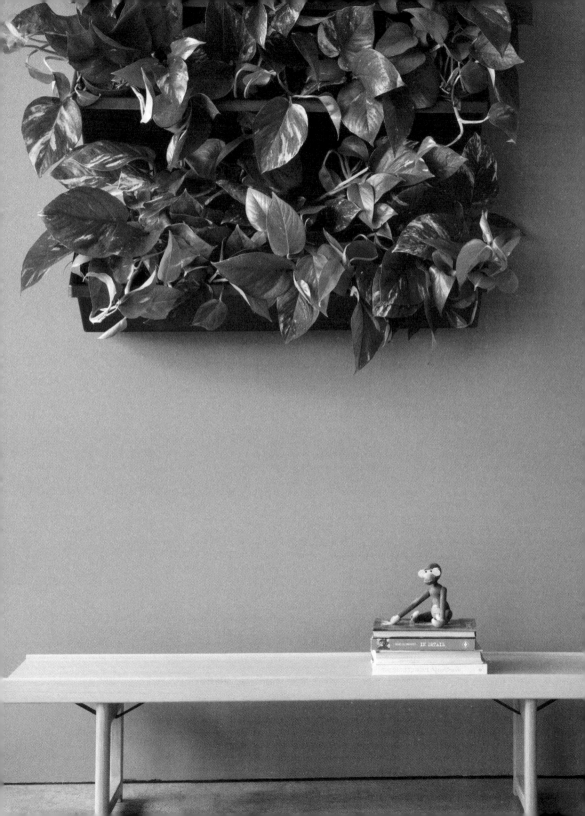

# FAQs

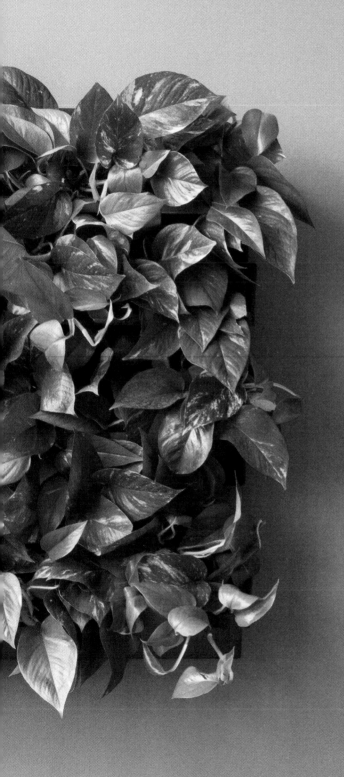

# STATEMENTS AND QUESTIONS

I have gathered several statements and questions I often hear about plants, plant walls, and the Forest Air system. I have addressed most of them in the text of the book itself, but if you are wondering about something specific without having read the whole book, or perhaps you might need a clear answer for others who have questions, I hope this list will be helpful.

**Let me tell you why I will never keep any indoor plants! It is because plants always die in my home. How would I be able to take care of the twenty plants in the Forest Air plant wall?**
**Answer:** The Forest Air system is designed especially for those of you who are not born gardeners. If you follow the simple rules closely, your plants will not die.

Isn't the maintenance of such a plant wall a lot of work?
Answer: The Forest Air system requires little maintenance. Watering is required only every third week. At the same time, you might notice that some of the plants will have overgrown. In this case, cut the part of the stem that is too long. That's all.

The Forest Air wall has twenty plants! Who would want to change the soil for all of them?
Answer: It is not necessary to change the soil.

Isn't it dangerous to keep green plants in the bedroom? Someone told me they use up all the oxygen during the night?
Answer: The change and use of oxygen is part of the plants' growth processes. At night, the use of oxygen may slightly increase, but a plant wall will never use oxygen in quantities that would interfere with human processes. There are simply too few of them to cause this.

My golden pothos has yellow leaves. What can I do?
Answer: Yellow leaves are part of the golden pothos's natural life cycle. It happens because the plant draws nourishment from the older leaves when they have reached maturity and need to be replaced. Wait until the leaf has become completely yellow before plucking it out.

Grandma/the florist/my flower textbook/a magazine/ my friend says that the plants will die if I follow your maintenance recommendations.
Answer: Your grandma/florist/flower textbook/magazine/friend have perhaps not put the Forest Air system into practice. My gardeners/my customers say that the plants simply keep growing.

Can the plants in the Forest Air wall give out harmful gasses?
Answer: The plants in the Forest Air wall will not expose you to any harmful gasses. On the contrary, they will reduce the production of many other harmful substances in the breathing air, as long as they receive correct care and continue to grow.

How often does the plant need to be fertilized?
Answer: The plant needs no fertilizing in the first year. Afterward, it can be fertilized with regular plant fertilizer on each watering, but use only 30 percent of the recommended dose indicated on the bottle.

Why can't I just keep some plants on the windowsill? Won't I have the same health benefits?
Answer: All growing plants that thrive in their environment will have good effects on the indoor climate and your health. A plant that doesn't thrive or grow will have the opposite effect. The Forest Air system is designed such that it makes it even easier to have healthy, growing plants, considering all the health advantages it implies.

Why is it necessary to purchase a Forest Air set fully equipped with flower cases and everything else? Isn't it possible to use regular flowerpots and hang them on the walls?

Answer: It is absolutely possible. The Forest Air system is primarily concerned with a set of solid rules for plants, watering, and plant care. The book provides instructions on how to build a system from scratch, if the readers are interested in doing so. In this case, purchasing a lamp and a couple of LED bulbs is necessary.

The landlord doesn't allow me to make holes in the walls. Can I still get a plant wall?

Answer: Of course. Place four flower boxes on top of each other on a shelf and use an adjustable floor lamp to provide correct lighting to the plants. You will have the same results.

Can I use a regular bulb? The plants can't actually read the instructions on the box.

Answer: No, plants are not smart enough to read, but the better the lighting conditions, the better they will grow. If the light is too weak, they will not grow at all. If you follow the instructions of the Forest Air system, the plants will thrive.

How can you know for sure that plants have an effect on our health? People come up with the darndest things.

Answer: In chapter I and 3 of this book I present research that proves that plants, both inside and outside, have a great impact on people's health and well-being. There are important researchers from Norway, Japan, and the USA who have researched this topic.

Isn't it very expensive to buy the special Forest Air plants? Can't I just use regular plants?
**Answer**: Forest Air plants are regular plants you can find in any flower shop. They are not expensive.

How can only a few indoor plants make any difference? Imagine how many trees there are in a forest, for example.
**Answer**: The research I make reference to in this book shows that even a small quantity of indoor plants have a great health impact.

Can the plant wall become the habitat of pests and harmful insects?
**Answer**: No insects other than the ones already naturally living in your climate area.

What if I am allergic?
**Answer**: In the thirty years I have been working with it, I have never heard of any allergic reactions to the plants we recommend having in the Forest Air system.

What if the plants contract a disease and pass it on to me?
**Answer**: Plants don't pass on diseases to humans.

What if children or pets eat the plants? Will they be sick?
**Answer**: Very few of the world's plants are actually edible. Indoor plants should not be eaten, but only ingesting a large quantity could lead to poisoning. If you cannot make sure that your children keep away from the plants, you can hang them higher up on the wall

or wait for a couple of years to get a plant wall until the children have become older and wiser. Some pets may become sick after eating certain plants. The same security measures that apply to children will work for pets as well.

**What if I use the healthy light you mention, but I go for artificial plants that don't require that much care?**
Answer: Artificial plants don't have any air-cleansing properties, despite looking nice. I don't belive that having plastic plants is pleasing, but I wish you good luck if that is what you want. I also hope you enjoy dusting.

**What illnesses can one get from living in poor lighting conditions? People have never had longer life expectancies or been healthier than they are today.**
Answer: Humankind has seen health revolutions in several fields, but long periods spent in poor lighting conditions have produced negative effects on perceived and actual health. I believe you will be surprised how powerful the effects actually are.

**Are golden pothos healthy for both animals and humans?**
Answer: I mentioned in previous chapters that golden pothos plants can be found in almost any office, home, and institution. While they are popular plants, golden pothos can be toxic for cats and dogs. If you have a pet, I would recommend placing your frame as high on the wall as possible, away from other surfaces that a cat could use to reach the plants. Also avoid placing the plant on the floor. For humans, excessive contact with the plant can lead to general skin irritation. Only touch the plant when watering or pruning.

There is too much work and too few benefits. I have personally seen more colorful plants or maybe even plants people can grow for food.

**Answer:** Both versions are possible, but the Forest Air system, as it is presented in this book, is about making it as easy as possible for everyone to have a green and beautiful indoor environment with the least amount of effort. If you feel the urge to create an even more advanced system on your own, it is of course possible. Perhaps you will have wonderful results you can use to impress your friends and family with, in addition to the self-satisfaction you will get. However, the health impact of the Forest Air system lies in it being an unnoticeable background to your day-to-day life, without requiring a great commitment or much care or attention.

# RESOURCES

You can purchase the materials needed for a Forest Air wall system at your local home improvement supplies store or online. Build your own or search online for indoor wall planters and LED bulbs. The Forest Air wall system is also available for purchase on the Skogluft website.

- https://skogluft.com
- https://www.homedepot.com
- https://www.lowes.com
- https://www.walmart.com

Golden pothos plants are available at your local garden store and also online.

- https://www.amazon.com
- https://www.thesill.com
- https://www.etsy.com
- https://jet.com

# ACKNOWLEDGMENTS

Hundreds of people have contributed their knowledge to this book. Over the thirty years I have worked in the field, the people I have come into contact with—customers, collaborators, colleagues, and professional acquaintances—have led me to new insights in so many areas. My contribution has been to systematize these insights and bring them together into useable practical concepts. I would like to thank all who have helped me along the way in this work—each and every one of them.

A few I must single out for particular thanks, for their kindness in volunteering to share their experiences with me for this book: So, special thanks to Tove Fjeld, Jan Grønbech, Turid Langli, Niels Bjørn Olsen, Beret Aspaas, and Richard Cooper. Your contributions have been decisive in giving this book authority and relevance.

Without Alexander's enthusiasm and vision this book would never have seen the light of day. Without Christian it would never have taken on the literary form it has. With her marvellous illustrations, Sunila has made it much easier to convey the practical message of the book. And thank you to my editor, Agathe, who dealt with all the corrections and revisions that arose along the way without a word of complaint. A big thank-you also to the rest of the fantastic team at Panta Publishing: Kristoffer, Lorna, Johan, and Kaja.

It has been a privilege to work with Panta Publishing. It gave me the chance to spread the practical concepts and ideas that underlie this book, and to share visions of a better, simpler, and greener life for people the world over. Without you this project would not have been possible. I thank you all.

# ENDNOTES

1. Bum Jin Park et al., "The physiological effects of *Shinrin-yoku* (taking in the forest atmosphere or forest bathing): evidence from field experiments in 24 forests across Japan," *Environmental Health and Preventive Medicine* 15, no. 1 (January 2010): 18–26.

2. Y. Ohtsuka et al., "Shinrin-yoku (forest-air bathing and walking) effectively decreases blood glucose levels in diabetic patients," *International Journal of Biometeorology* 41, no. 3 (February 1998): 125–27, https://www.ncbi.nlm.nih.gov/pubmed/9531856.

3. Liisa Tyrväinen et al., "The influence of urban green environments on stress relief measures: a field experiment," *Journal of Experimental Psychology* 38 (June 2014), 1–9, http://www.sciencedirect.com/science/article/pii/S0272494413000959.

4. Gregory N. Bratman et al. "The benefits of nature experience: improved affect and cognition. *Landscape and Urban Planning* 138 (June 2015): 41–50, http://www.sciencedirect.com/science/article/pii/S0169204615000286; Gregory N. Bratman et al., "Nature experience reduces rumination and subgenual prefrontal cortex activation," abstract, *Proceedings of the National Academy of Sciences of the United States of America* 112, no. 28 (July 14, 2015), 8567–8572, http://www.pnas.org/content/112/28/8567.abstract.

5. J. W. Han, "The effects of forest therapy on coping with chronic widespread pain: physiological and psychological differences between participants in a forest therapy program and a control group," abstract, *International Journal of Environmental*

*Research and Public Health* 13, no. 3 (March 2016): 255, https://www.ncbi.nlm.nih.gov/pubmed/26927141.

6. United Nations, Department of Economic and Social Affairs, Population Division (2015), *World Urbanization Prospects: The 2014 Revision.* (ST/ESA/SER.A/366), https://esa.un.org/unpd/wup/Publications/Files/WUP2014-Report.pdf.

7. B. C. Wolverton, Anne Johnson, and Keith Bounds, *Interior Landscape Plants for Indoor Air Pollution Abatement* (Stennis Space Center, Miss.: National Aeronautics and Space Administration, 1989), https://ntrs.nasa.gov/archive/nasa/casi.ntrs.nasa.gov/19930073077.pdf.

8. A. Van Dortmont and J. Bergs, Onderzoek planten en productivieit. Eindrapportage. (Final Report: Investigation of plants and productivity. In Dutch.) (Honselersdijk, the Netherlands: Bloemenbureau Holland, 2001).

9. R. S. Ulrich and R. Parsons, "Influences of passive experiences with plants on individual well-being and health," in D. Relf, ed., *The Role of Horticulture in Human Well-Being and Social Development: A National Symposium* (Portland, Oregon: Timber Press, 1992), 93–105.

10. Ruth K. Ranass et al., "Benefits of indoor plants on attention capacity in an office setting," *Journal of Environmental Psychology* 31, no. 1 (March 2011): 99–105, http://www.sciencedirect.com/science/article/pii/S0272494410001027?via%3Dihub.

## ABOUT THE AUTHOR

Jørn Viumdal began his career as a
mechanical engineer, but in the 1980s
he experienced an awakening:
"The world is more than mechanics.
The world is biological too!" In 1987
Jørn contacted NASA, which had just
started research into what was needed
to make people in space stations
feel comfortable. Through Jørn, a
collaboration with the Norwegian
University of Life Sciences in Ås was
inaugurated with the aim of finding
out how to make people feel healthy
and comfortable indoors. Since then
Jørn has been working to bring
elements from nature into homes,
schools, and offices.

Photo: Oda Hveem